IMAGES
of America

BRECKSVILLE

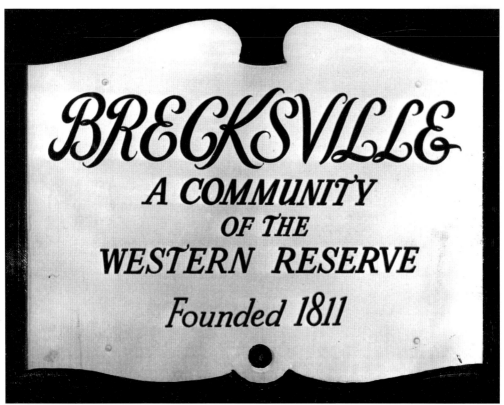

BRECKSVILLE SIGN, 1957. (*Cleveland Press*, courtesy of Special Collections, Cleveland State University.)

This book is dedicated to the memory of
Elizabeth Bailey Hoffman.

IMAGES
of America

BRECKSVILLE

David Borsvold

ARCADIA
PUBLISHING

Published by Arcadia Publishing
Charleston SC, Chicago IL, Portsmouth NH, San Francisco CA

Printed in the United States of America

Library of Congress Catalog Card Number: 2004100625

For all general information contact Arcadia Publishing at:
Telephone 843-853-2070
Fax 843-853-0044
E-mail sales@arcadiapublishing.com
For customer service and orders:
Toll-Free 1-888-313-2665

Visit us on the Internet at www.arcadiapublishing.com

BETTY HOFFMAN, FORMER PRESIDENT OF
THE BRECKSVILLE HISTORICAL ASSOCIATION.
Though this book was written after her passing,
it owes a great deal to her work.

CONTENTS

Acknowledgments 6

Introduction 7

1. Landing in the Cuyahoga Valley 9

2. Historic Landmarks and Images 23

3. Government, Politics, and Business 59

4. People and Celebrations 83

5. Brecksville's Historic Homes 113

ACKNOWLEDGMENTS

This book is a collaboration. The Brecksville Historical Association's participation in the project brought with it not only an indispensable archive of photographs and artifacts, but also the interest and energy of a group of people who are passionate about preserving Brecksville's past. The invaluable input of the members of the Association consisted not only of checking the manuscript for accuracy, but also remembering a thousand details that are not available anywhere in print.

The stated missions of the Association are: "To perpetuate the memory of the pioneers and early settlers of Brecksville and the surrounding area; to collect, preserve and display historical and genealogical documents and relics commemorative of the area; to maintain a suitable Museum and Library in which to house, display and catalogue such collections; to disseminate information and historical data to the residents of Brecksville and surrounding areas that may be viewed with a rich heritage to the past; to foster a spirit of neighborliness and stimulate the fundamentals of American Democracy; and to do all things necessary and incidental to carrying out the above missions."

At the archives of the Historical Association, Sylvia Fowler and Carol Host were tireless and enthusiastic in locating photographs and documents, as well as giving good advice and answering numerous questions from memory. Several Brecksville residents lent photographs: Mae Bejcek, Bev Clark, Shirley (née Eucher) Elish, the Estate of Elizabeth Noble Klein, Cheryl A. Rudolph, the Estate of Lydia Tucker, Arlene Griffith, Meredith Giere, Walter Zimlich, the Estate of Elizabeth (Betty) Hoffman, the Estate of Dorcas Snow, Thomas and Sylvia Fowler, and Mayor Jerry Hruby. In the text, photographs lent by the Brecksville Historical Association are identified as "Courtesy of B.H.A.," whereas other photograph credits are written out in full. Sylvia Fowler, Carol Host, Johanna Klein, Kay Broughton, Wally Zimlich, Shirley Elish, Elton Pay, Joan Carouse, and Mayor Jerry Hruby greatly enhanced the project with their painstaking review of the text.

Thanks are also due for use of the photographs from the *Cleveland Press* to William C. Barrow and his staff at the Special Collections of the Cleveland State University Library.

Brecksville Historical Association President Sylvia Fowler adds a note regarding the book's dedicatee:

"Betty Hoffman, who passed away in April 1995, had a love for history, she was a Trustee of the Association, and President from 1957–1959. During her tenure with the Association Betty researched and photographed over 100 century homes in Brecksville built, *circa* 1874–1974. The Association is ever mindful of the work she did as the 'founding mother' of a photographic history of century homes. She has been an impetus to the Association to continue her dream.
The Association is indebted to the families of Betty and Bob Hoffman, who have made memorial donations in her name to make this book possible. While it does not feature all of her research and photographs, we hope you will enjoy this pictorial image of Brecksville—because of Betty and her love of the history of our community."

INTRODUCTION

In the center of Brecksville, Ohio, immaculately preserved historic buildings blend harmoniously with the surrounding modern businesses and city facilities. When driving through the busy heart of town today, it is difficult to imagine the primeval forest that had to be cleared by the earliest settlers. Fortunately, amid steady development over the last two centuries, the City has always kept a firm focus on the preservation of its past; indeed, the recorded history of the Brecksville area stretches back over more than 200 years.

In 1786, forced by the fledgling United States government to relinquish its deed to a large swatch of land in the Northwest Territory because of claims that conflicted with those of New York, Virginia, and Massachusetts, the state of Connecticut managed to keep possession of 120 miles of land along the south shore of Lake Erie in Pennsylvania and Ohio. Officially recognized by the federal government as "The Western Reserve of Connecticut," this rolling, forested land was attractive to New Englanders for its striking similarity to the terrain they knew. In 1795, Connecticut authorities sold the three million acres of the Western Reserve for $1.2 million to the Connecticut Land Company, a group of 35 men led by General Moses Cleaveland. Within the next year, the company surveyed land for settlements east of the Cuyahoga River.

Ohio became the 17th state on March 1, 1803. Twenty-eight months later, area Native Americans—Chippewas, Ottawas, Wyandots, and Andastes—were persuaded to give up land west of the river, and the rest of the Western Reserve, including the future area of Brecksville, was surveyed. Cuyahoga County, comprising not only the growing settlement of Cleveland but the entire northern half of the Cuyahoga Valley, was created in 1807.

As the members of the Connecticut Land Company sold off their parcels, the wilderness was gradually settled, the pioneers arriving by boat from Lake Erie via the Cuyahoga (derived from a local Native American word meaning "crooked river"). One of these, surveyor Seth Paine of Williamsburg, Massachusetts, took the Columbia Trail up the hill from the river landing in 1811 and claimed the area of what is now Broadview Road at Boston Road. Eight more settlers joined him that same year and built oak or whitewood log cabins in the woods.

For settlers surrounded by bears, rattlesnakes, mountain lions, and a population of understandably hostile Native Americans, frontier life was extraordinarily hard. Moving up the steep, heavily forested western hillside of the Valley without graded roads and clearing the land above presented daunting challenges, and basic services and communications were lacking. With physicians few and far between, fevers and simple illnesses were even more life-threatening than usual.

A number of Connecticut farmers migrated to the area after the bitter, killing frosts of 1816 in the East. Once cleared, the land of Brecksville was highly arable, and Chippewa Creek and other streams provided excellent sites for mills.

The Township of Brecksville (incorrectly listed as "Bricksville" in early county records) was established in 1811. Its name comes from a Massachusetts family dating back to 1630. Robert Breck, a Revolutionary War soldier who became Postmaster of Northampton and also invested in Western Reserve land, died in 1802 and left his land claim to his two sons. One of the sons was Colonel John Breck, who served in the war of 1812. While he was given authority to resurvey the land west of the Cuyahoga, he never came to Brecksville. His cousin,

Reverend Joseph Hunt Breck, was the first of the family to live there, and he built a house in 1832 (though he did not settle permanently in the Township). At about the same time, the three sons of Colonel John Breck and Clarissa Allen Breck came to Brecksville: John Adams Breck, Dr. Edward Breck, and Theodore Breck. Edward married Clarissa King and lived in the brick house opposite the town square, while John Adams (married to Rachel Tucker) moved in at 6711 Mill Road. Theodore was a farmer, notary, and businessman, and served in the Ohio House and in the Senate; his great-grandson, Dr. Theodore Breck (1866–1934), would become one of Brecksville's most revered citizens and the last of the family to live there.

Several streets in Brecksville today bear the names of pioneer families who were present in the Township's earliest decades. Most of them arrived by the same route—the Cuyahoga River.

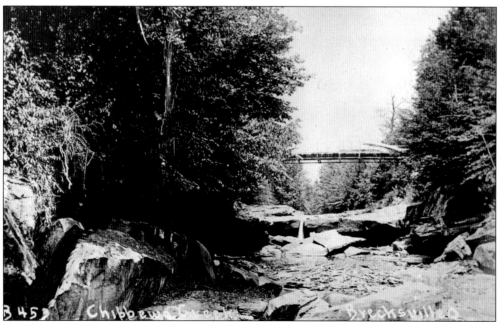

OLD ROUTE 21 BRIDGE OVER CHIPPEWA CREEK, LOOKING WEST. Just above the falls was a small rock pool known as the "Devil's Wash Bowl." (Courtesy of B.H.A.)

8

One

LANDING IN THE CUYAHOGA VALLEY

When the War of 1812 ended, a new influx of settlers came to Brecksville, landing on the banks of the Cuyahoga and taking the trail uphill. Many of them were farmers, facing prohibitive overland freight charges for shipping crops back east. If Lake Erie could somehow be linked to the Ohio River, commerce and settlement might be greatly accelerated. In 1788, George Washington had proposed the creation of a route connecting the Cuyahoga, Big Beaver, and Muskingum rivers to accomplish this task. Thirty-seven years later the Ohio Legislature authorized construction of an "Ohio and Erie Canal" from Cleveland to the Ohio River town of Portsmouth. The canal paralleled the Cuyahoga River down from Cleveland, along the eastern edge of Brecksville, and southward past the Portage Summit at Akron over a route of 308 miles. The Cuyahoga Valley section of the canal that opened in 1827—requiring 44 locks to negotiate a nearly 400-foot drop in elevation—immediately began to spur development. Soon, however, another fast-growing form of transportation would render the canals suddenly obsolete.

Fast, efficient, and ruthlessly competitive, the railroads quickly grew to national prominence before the Civil War as shippers and passengers flocked to the rails. Grading the uneven terrain of the Cuyahoga Valley presented a challenge, but between 1873 and 1880, the 75-mile-long Valley Railroad was put in. With trains now providing easy access, much of the river district was cleared and farmed. Brecksville's depot accommodated both passengers and freight. Many families living on what was then Snow Road alighted from the train at Station Road and relied upon Beecher Bell, the town hack, to get them safely over the rough terrain in his carriage.

At about this time, too, Brecksville residents and many rail travelers from Cleveland began to enjoy the recreational possibilities of the Cuyahoga Valley. Woodland trails offered abundant hiking and nature study, and the nearly empty canal was ideal for leisurely boating. But the area changed over the following decades: by the 1960s, the suburban boom was pushing into the Valley. I-271, the Ohio Turnpike, high-tension electrical lines, home building contractors, a proposed dam and lake, and the Richfield Coliseum seriously threatened the pastoral seclusion of the Valley that was safeguarded only in parks such as the Brecksville Reservation of the Cleveland Metroparks.

Akron environmental activist John Seiberling, along with the Cuyahoga Valley Association and conservation groups, began to protest Valley development and to warn of frightening environmental consequences to come. It was soon recognized that the only financially feasible way to save the Cuyahoga Valley from urbanization was to have it designated as a National Park.

In March 1971, Seiberling (now a U.S. Representative) introduced a bill to create such a park in the Valley, but it sank like a stone in committee. Concerned groups from communities all along the river joined in a determined, sustained publicity campaign. Gradually public opinion began to swing towards the preservationists, and Seiberling reintroduced the bill in 1973, concurrent with the creation of a Cuyahoga Valley Park Federation. H.R. 7077 was approved by Congress and signed by President Ford in 1974, but the battle was not over. For a decade, the Cuyahoga Valley Homeowners and Residents Association resisted (with little success) the National Recreation Area's relentless acquisition of land that forced some to leave their valley homes.

Today, with 33,000 acres preserved, old riverside buildings spectacularly rehabilitated, and park services steadily increasing, the CVNRA is recognized as the jewel of Northeast Ohio and one of Brecksville's major attractions.

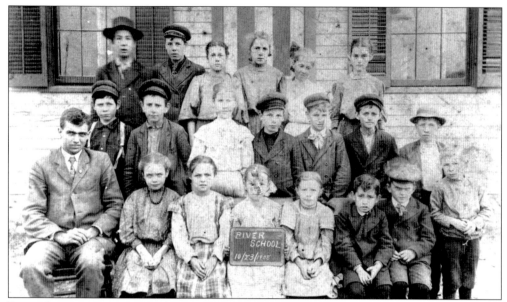

RIVER SCHOOL, 1908. Many who lived by the Canal had hard lives, what with a cholera outbreak, malarial mosquitoes, and a dangerous neighborhood to live in. Of the local men and boys who had worked on the construction of the canal, 100 died, and many more were sickened (whiskey being the standard prescription for "the shakes"). School District No. 3 held its classes in this building at the intersection of Route 82 and North Riverview Road. Recalled one member of the Dillow family who was schooled here: "It got the name of being a very bad school. Seldom was a teacher able to go through the term. The boys would simply turn them out." (Courtesy of Jerry N. Hruby.)

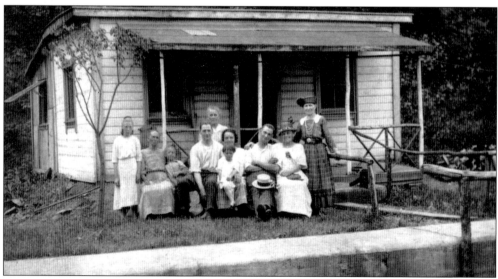

HOUSE BY THE CANAL, c. 1914. The Hartwig and Epple families look out from a house on flood-damaged Lock 17. Various attempts at restoration of the Ohio and Erie Canal had been made in the decade preceding this photograph, but on March 23, 1913, Ohio's canal system was sacked in one mighty blow. After a winter of record snowfall, storms dumped an abnormally heavy amount of rain on the state, and reservoirs spilled over into the canals, destroying aqueducts and locks. (Courtesy of B.H.A.)

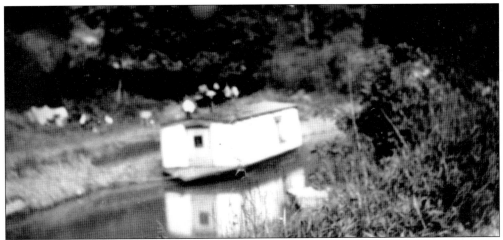

CANAL BOAT, c. 1920. The photograph is rather out of focus, but is worth a look since images of canal boats in Brecksville are rare indeed. By this time, the canal's days as a transportation route were long over, although pleasure craft still floated in its quiet waters. In 1989, the portion of the canal that stretches from Rockside Road to Piney Dam became part of the Cuyahoga Valley National Recreational Area, and its maintenance fell to the National Park Service. North of Rockside Road, the old canal is still used to provide water to valley industries. (Courtesy of B.H.A.)

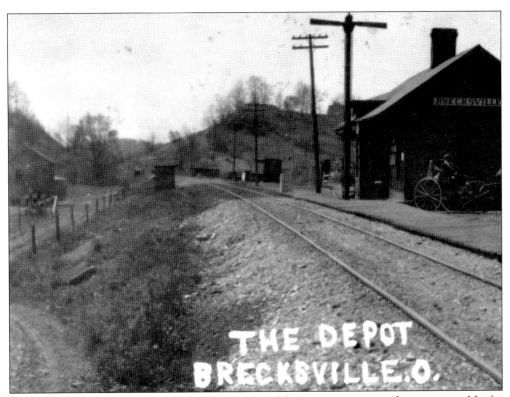

BRECKSVILLE DEPOT. When the Valley Railroad began operation, it became possible for Brecksville dairy farmers to ship milk and cream twice a day to Cleveland and Akron. (Courtesy of B.H.A.)

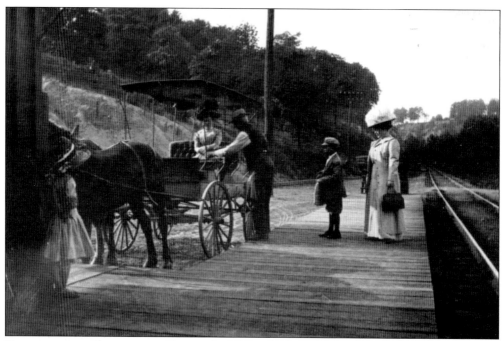

PASSENGERS AT BRECKSVILLE DEPOT. In 1878, a letter arrived on the desk of the Honorable Theodore Breck suggesting that he obtain a piece of land in the Valley from Yorkshire-born William Hardesty, who had built a sawmill near the canal and rail line. A road to the station was put in on this land, and it was paved in 1913 replacing the cinders originally thrown down to cover the mud and making access to town much easier. (Courtesy of B.H.A.)

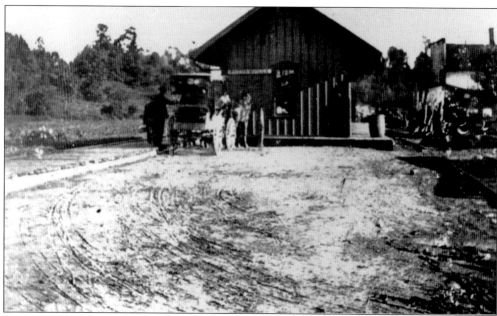

ARRIVING IN STYLE. Passengers are met at the depot. Beginning in the 1880s, many Clevelanders began escaping the City's smoke and noise with rail excursions to rural Brecksville. (Courtesy of Jerry N. Hruby.)

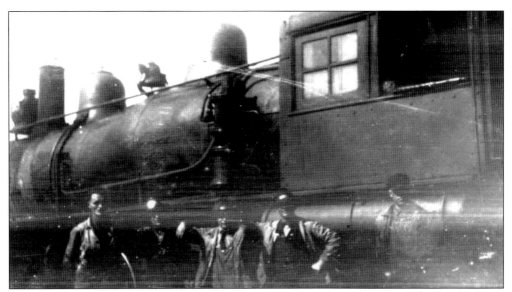

Baltimore & Ohio Locomotive and Crew on the Valley Line in Brecksville, c. 1930. In 1890, the Valley Railroad had been absorbed by the B&O. Early bankruptcy impeded operations until, in 1895, the road was reorganized as the Cleveland Terminal & Valley Railroad. The B&O took over again in 1915, continuing freight and passenger service between Cleveland and Akron. (Courtesy of Jerry N. Hruby.)

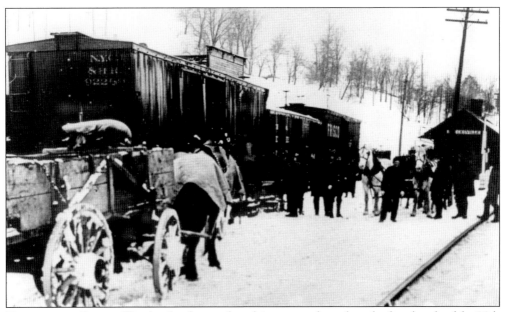

Transfer of Goods. Wooden freight cars date this scene no later than the first decade of the 20th century. Goods were brought to the depot in the Valley and then moved up the hill on horse-drawn carts. The Valley line never boasted much traffic, and like other U.S. railroads, the B&O suffered a steep decline in passenger revenues beginning in the mid-1950s. The last passenger train on the Valley line ran in 1963, a year after the B&O/Chesapeake & Ohio merger (the new company's equipment began to display the logo of the Chessie System in 1972). With freight business very light, Chessie abandoned the Valley line in 1985. (Courtesy of Jerry N. Hruby.)

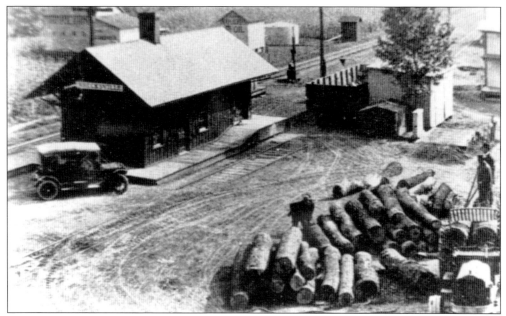

LUMBER TRAFFIC AT THE BRECKSVILLE DEPOT. Local timber cutting brought the railroad some degree of traffic. No freight line has ever passed near to the center of town, nor did Brecksville have streetcars (an interurban line, which might have carried some freight to Brecksville Center along with its passengers, was proposed but never realized). (Courtesy of Jerry N. Hruby.)

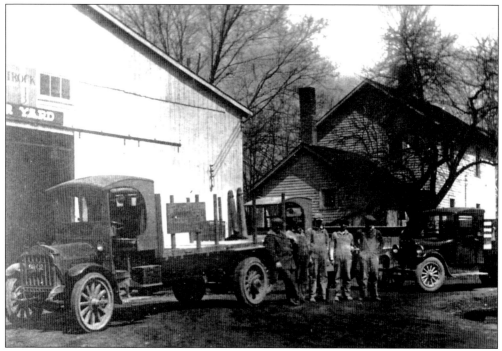

LUMBER YARD. Timber was brought in on railroad cars to Vaughn's Siding, then unloaded and hauled via Station Road to this lumber yard on Mill Road. (Courtesy of B.H.A.)

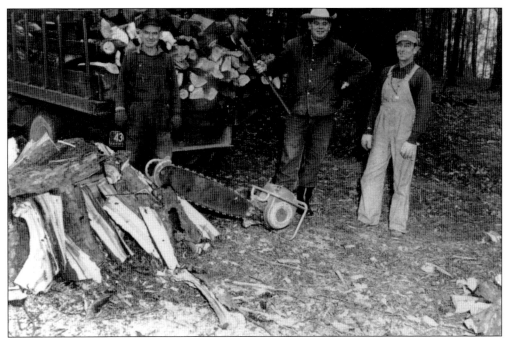

BRECKSVILLE LUMBERJACKS. In the days when tremendous amounts of land were being cleared from the town's abundant forests, lumber merchants had plenty to smile about. (Courtesy of Meredith Bourne Giere.)

DEPOT AT VAUGHN'S SIDING. This rare photograph establishes the relative positions of the depot and surrounding buildings. (Courtesy of B.H.A.)

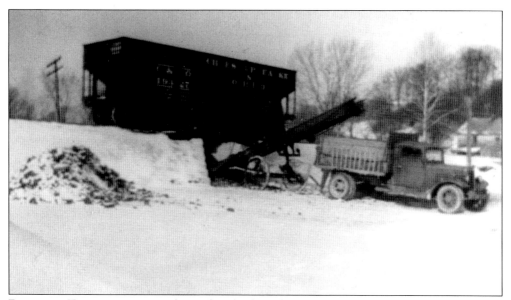

RAILROAD TRANSFER. Raymond Bejcek unloads coal from a C&O hopper into his truck at the siding in January 1947. A member of the first class to graduate from the new Brecksville High School in 1930, Ray worked variously as a school bus driver, owner of a coal supply company, and an electrician for Cleveland Trust before he retired in 1977. He served for 28 years as a volunteer firefighter (18 years as Fire Chief) and as an important member of the Theodore Breck Masonic Lodge. He was voted Brecksville Man of the Year in 1979. (Courtesy of B.H.A.)

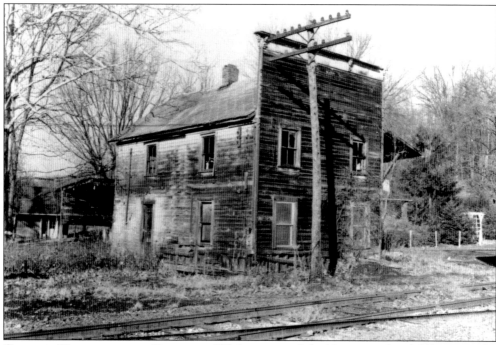

COMPANY HOUSING BY THE RAILROAD. While many such buildings rotted and fell apart in the mid-20th century, some were restored for Park Service offices beginning in the 1970s. (Courtesy of B.H.A.)

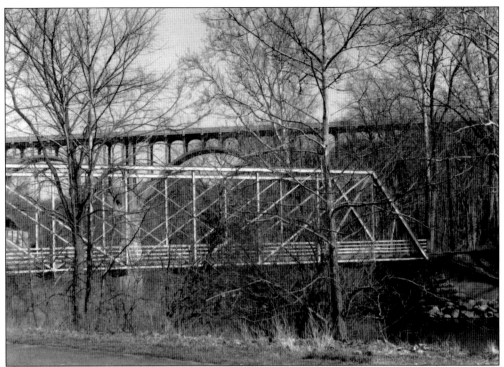

RAILROAD BRIDGE AND VIADUCT. The railroad bridge was removed and sent to Elmira, New York, for restoration before being returned here. Today it is a walking bridge in the Cuyahoga Valley National Recreation Area. (Courtesy of B.H.A.)

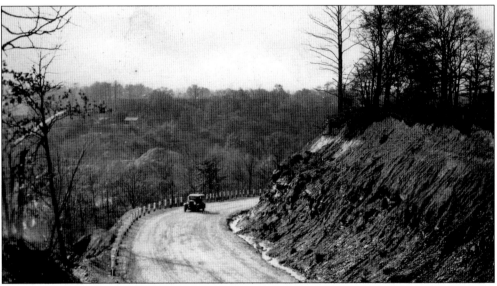

SCENIC VALLEY MOTORING. This photograph looking northwest from Northfield Hill was taken on May 18, 1929. Roads began to trace the Cuyahoga Valley about a century ago, and motorists, along with truckers and the new commerce they brought, soon began to change the look of the Valley. (Courtesy of Jeannette McCreery Eucher Collection.)

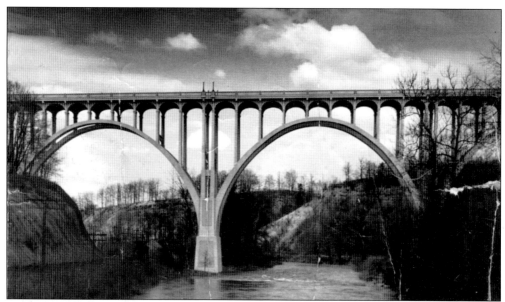

BRECKSVILLE-NORTHFIELD HIGH LEVEL BRIDGE, APRIL 20, 1933. The 140-foot-high bridge, the highest reinforced concrete span yet designed and built by the State of Ohio, was at that time the next high-level crossing of the Cuyahoga Valley south of the industrial flats in Cleveland. The bridge, requiring 13,500 cubic yards of concrete (850,500 bags of cement) and 1.5 million pounds of steel, cost $426,295 to build. Opened to traffic on January 2, 1932, it superseded the old valley-floor profile of Route 82, which had dangerously steep hills and a grade crossing with the B&O Railroad. (Courtesy of B.H.A.)

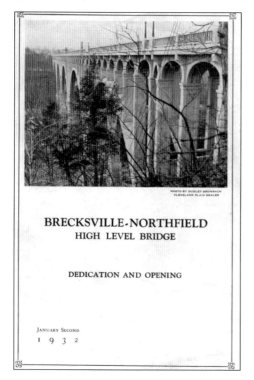

PHOTO BY DUDLEY BRUMBACH
CLEVELAND PLAIN DEALER

BRECKSVILLE-NORTHFIELD
HIGH LEVEL BRIDGE

DEDICATION AND OPENING

JANUARY SECOND
1 9 3 2

BRECKSVILLE-NORTHFIELD BRIDGE DEDICATION AT BRECKSVILLE HIGH SCHOOL, 1932. This was a festive occasion. The Brecksville Band and the M.T.N. Combined Band played commemorative music, and the colors and escort were provided by the Cuyahoga County Council of the American Legion. Speakers included Ohio Governor George A. White, Brecksville Mayor B.W. Harris, the Mayors of Northfield and Sagamore Hills, the Cuyahoga County Engineer, and officials from the Department of Highways and the B&O Railroad. (Courtesy of B.H.A.)

SLEEPY HOLLOW COUNTRY CLUB. This building's arches framed evocative views into the Valley before the structure was demolished in the 1980s. The first nine holes of the beautiful golf course here opened in 1921. (Courtesy of B.H.A.)

NATURAL BEAUTY IN THE VALLEY. Riverview Road today is part of the "Scenic Byway" that parallels the Cuyahoga River. Brecksville is distinguished from other Cuyahoga County cities by the fact that one-third of its area is parkland, frequently referred to as part of the "Emerald Necklace." Today the 2,500 acres of the Brecksville Reservation of the Cleveland Metroparks are equipped with picnic areas and facilities for softball, horseback riding, and golf. Its paved fitness trail offers hikers, bicyclists, and runners superb views of the valley scenery. In the winter, cross-country skiing is also popular here. (Courtesy of B.H.A.)

FITZWATER HOUSE, RIVERVIEW ROAD, 1960S. John and Sabra Fitzwater and their four sons came to Brecksville in 1836, exchanging their Pennsylvania sawmill for 100 acres overlooking the Cuyahoga River and building this house in 1840. The Fitzwaters lived off the land and ate the large fish they caught in the river. They gave land for a school in their district (see p. 10), and John served for 16 years as a Township Trustee. They had two more sons in Brecksville, and in years to come, their boys would marry women from other respected families: Dillow, Packard, Eaton, Pratt, and Hunt. Eventually John and Sabra—feeling that the area was getting too crowded—moved to Tennessee, where each passed away in 1874. (Courtesy of the Estate of Elizabeth B. Hoffman.)

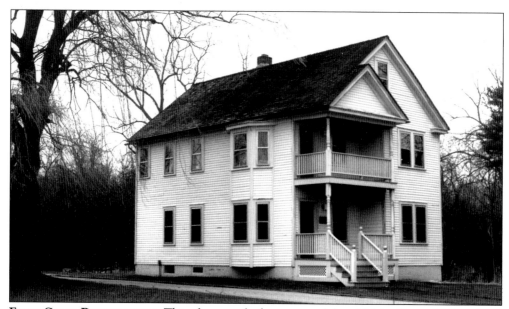

FIRST-CLASS RESTORATION. This photograph shows one of the old Jaite Paper Mill workers' quarters on Riverview Road in 2003, after being restored by the Park Service. Others were demolished. (Courtesy of B.H.A.)

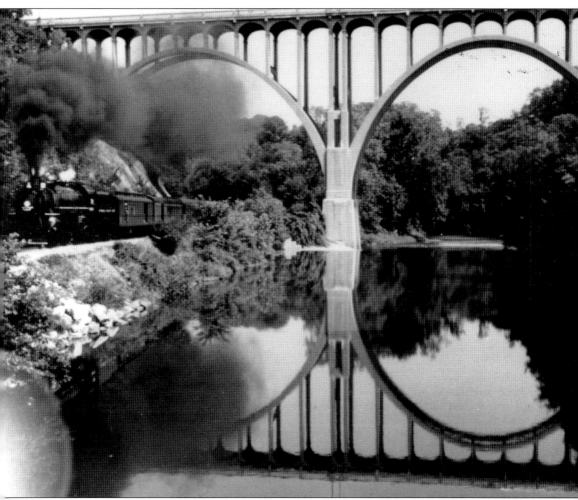

CUYAHOGA VALLEY LINE. In 1967, executives of the Cuyahoga County Fair and Hale Farm unsuccessfully proposed the creation of a steam locomotive excursion train by the B&O. Cleveland business leaders began new efforts in the 1970s to interest the Chessie System in the project. In 1975, the Cuyahoga Valley Preservation and Scenic Railway Association began running round-trips from the Cleveland Zoo to Akron's Quaker Square with equipment lent by the Midwest Railway Historical Foundation. In 1984, Chessie announced the abandonment of the Valley route. The National Park Service purchased the track, and the CVL reopened in 1988. Today the nationally celebrated Cuyahoga Valley Scenic Railroad features a roster of historic diesels and passenger cars. (Courtesy of B.H.A.)

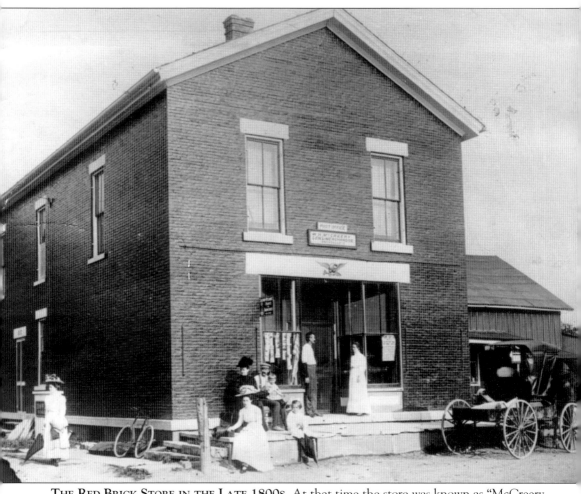

THE RED BRICK STORE IN THE LATE 1800S. At that time the store was known as "McCreery General Merchandise." The object to the left of the building, thought by many to be a gas pump, was in fact a scale used for weighing grain. (Courtesy of B.H.A.)

Two

HISTORIC LANDMARKS AND IMAGES

Brecksville has long been renowned for the charming New England flavor it brings to northeast Ohio, and has always exercised a policy of controlled development to maintain that prestige. After the founding of the Township of Brecksville in 1811, the local industry was mostly agrarian apart from a few mills and small businesses. Regional tourism began to grow strongly in the 1880s, as Clevelanders and Akronites took advantage of improved transportation to vacation in Brecksville.

Cars, roads, and gas stations began to proliferate around 1910, and bus service to East 71st Street in Cleveland began on May 1, 1911. With a population still fewer than 1,500, Brecksville was incorporated as a village under the laws of the State of Ohio in 1922. Growth was accelerating and traffic with it. When it became known in 1929 that a new road surface for Route 21 was in the works, concerns began to be raised about preserving Brecksville's quiet way of life. Historic buildings were being remodeled or moved to make way for the widening of roads. The first traffic light appeared in the fall of 1930 at the intersection of Route 21 and Royalton Road, and the newly widened Brecksville Road opened on October 18, 1930. The spectacular new viaduct over the Cuyahoga River was completed in 1931. It became the focus of a great deal of east-west traffic from a wide area, since there were very few high-level crossings of the Valley as yet. In 1937–1938, Royalton Road (Route 82) was upgraded and widened: homes were moved, farms were displaced, and old and beautiful trees were felled.

The real explosion of traffic in Brecksville, however, would begin in the 1950s. On October 1, 1955, the Ohio Turnpike opened with a huge span over the Valley and an exit at Route 21 in Brecksville. The Brecksville Motor Hotel was built in 1958, and other new businesses sprung up to cater to the travelers passing through town. With its population passing 5,000, Brecksville was accorded city status in 1960.

As this unparalleled period of growth has continued over the last 40 years, city leaders, businesses, and homeowners have done a remarkable job of preserving the elements of natural and architectural beauty that have typified Brecksville throughout its history. The 1990s saw a tremendous increase in development, as well as continued prosperity: the 2000 U.S. Census showed a population of 13,382, and in 2003, the average value of a new home in the city was $396,000.

In the following pages are classic images of many of Brecksville's civic landmarks, as well as the life and traditions that grew around them.

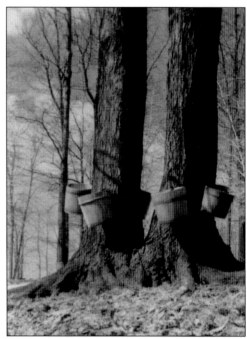

(*Left*) OLD OAKEN BUCKET ALONG THE PLANK ROAD. This bumpy toll road, which received heavy horse traffic, went from Wallings Corners to Cleveland. (Courtesy of B.H.A.)

(*Right*) BRECKSVILLE MAPLE SYRUP. Buckets are in place to collect sap to be boiled for syrup. Many people who came from New England to the Western Reserve found to their delight that the maple syrup made in northeast Ohio rivaled that of Vermont. In the early days, a wood or tin spike was driven into the tree, and the filled buckets ready for boiling were carried away with the use of shoulder straps. (Courtesy of Meredith Bourne Giere.)

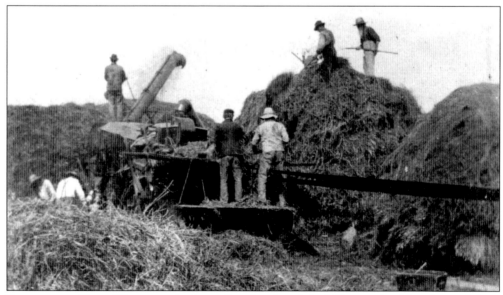

BRECKSVILLE FARM WORKERS. In the earlier decades of the Village, mixed farming and dairy farming were the rule, rather than specialty farms. (Courtesy of Meredith Bourne Giere.)

WOOL COMPANY LETTER. The quality of the penmanship, both in the letterhead and the body of the letter itself, is astonishing. (Courtesy of B.H.A.)

SCENE IN BRECKSVILLE FARMYARD. It is not possible today to determine the location or the names in this marvelous photograph, but it is evocative of a more genteel era. (Courtesy of B.H.A.)

MOVING THE BIG TREES. Many building materials and railroad ties used locally came from Brecksville's own trees. The fellow on the cart, Arlene Griffith's father, Forest Elmer, certainly has the easier job at the moment. (Courtesy of Arlene Elmer Griffith.)

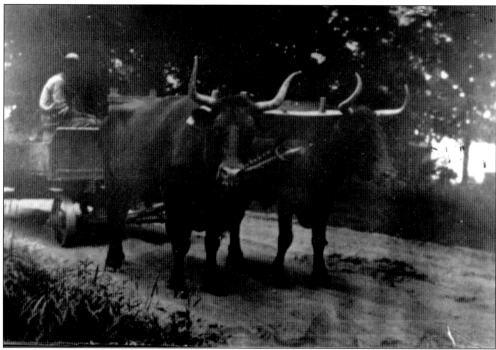

OXEN PULLING A CART. Horses were not the only way to move a load of goods in Brecksville's early decades. (Courtesy of Meredith Bourne Giere.)

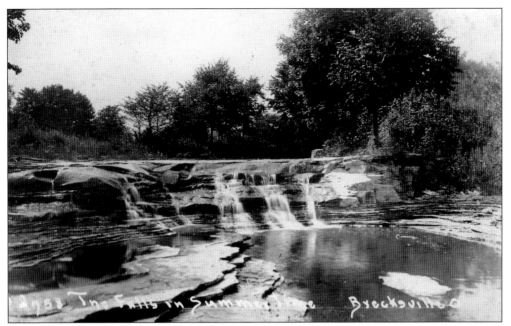

CHIPPEWA FALLS IN SUMMERTIME. In the years between 1880 and 1910, Brecksville's woodland retreats were popular destinations for vacationers from Cleveland. (Courtesy of B.H.A.)

CHIPPEWA SWIMMING HOLE. Brecksville had no organized swimming in the early decades, but many locals frequented this area during the summer. There was also a sulphur spring to the north that was patronized by many people who believed that a soak in its waters would improve their health. (Courtesy of B.H.A.)

GRIST MILL, 1903. Located at the intersection of Brecksville and Fitzwater Roads, the mill was purchased by John Eucher, a Civil War veteran, from Anthony Eckenfeldt for $5,000. (Courtesy of Jeannette McCreery Eucher Collection.)

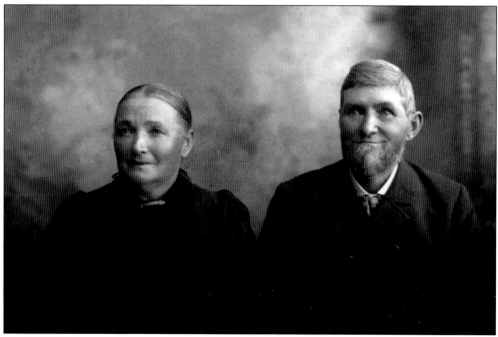

OWNERS OF THE GRIST MILL. This photograph shows Magdalena and John Eucher. (Courtesy of Jeannette McCreery Eucher Collection.)

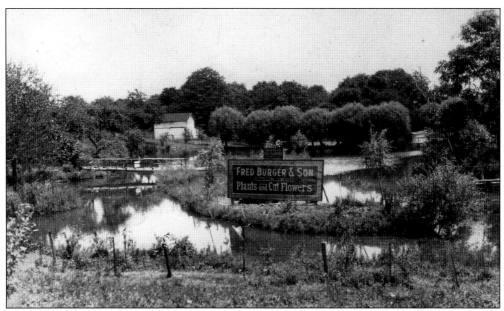

THE OLD MILL POND, 1925. This pond was adjacent to the Eucher mill. (Jeannette McCreery Eucher Collection.)

FRED BURGER AND SON. This floral receipt comes from the business seen in the photograph above. Note that in 1931 a geranium cost only 18¢! (Courtesy of B.H.A.)

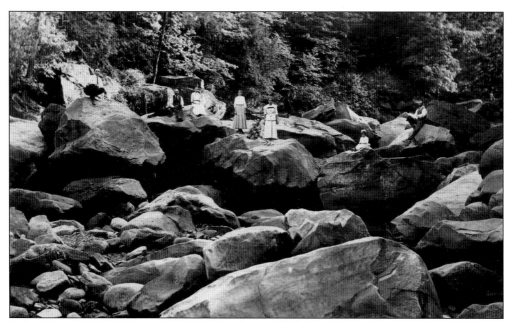

CHIPPEWA CREEK RAPIDS, c. 1910. This place, called "The Rocks," attracted hikers and the more rugged sort of vacationers. Rattlesnakes congregated here too, before they were virtually exterminated from northeast Ohio. (Courtesy of B.H.A.)

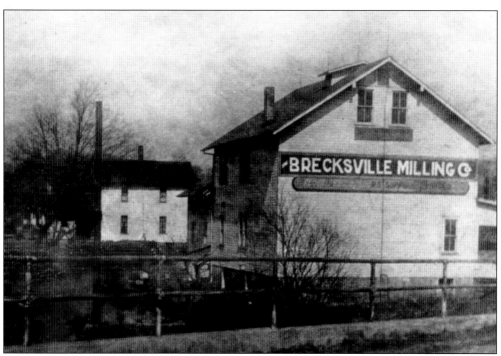

BRECKSVILLE MILLING COMPANY. After the old Wiese Bros. building burned down (see next page), Ernest built this mill in 1916, and it became one of Brecksville's most renowned businesses. In 1920, the mill was purchased by Bert Harris, who ran it with Harry Perry. Ernest Wiese went into carpentry, helped by his son Ernest Jr. (Courtesy of B.H.A.)

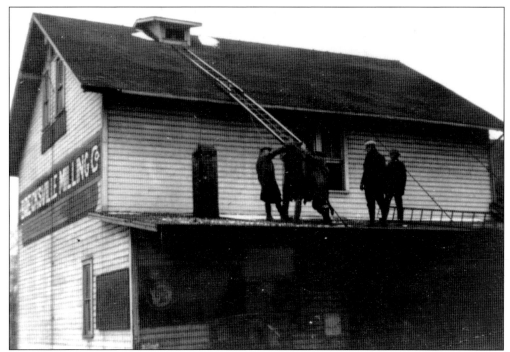

FIREMEN PRACTICE A LADDER RESCUE. This was the town's first fire drill after the purchase of a 1927 Ahrens Fox Pumper, which replaced an old chemical fire engine that had been mounted on a Dodge car chassis. (Courtesy of Jerry N. Hruby.)

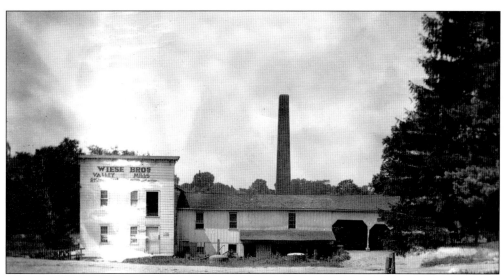

WIESE BROS. GRIST MILL. The mill, built in 1813 by Lemuel Hoadley as a log-grist mill and sawmill, was located on Chippewa Creek at Mill and Brecksville Roads. Hoadley eventually sold it to a Mr. Neubrandt, who remodeled it and added rollers for grinding flour. Neubrandt left Brecksville about a century ago, and during 1903–1904, the mill stood idle. It was purchased and remodeled by Ernest Wiese in 1905 and destroyed by fire in 1914. (Courtesy of B.H.A.)

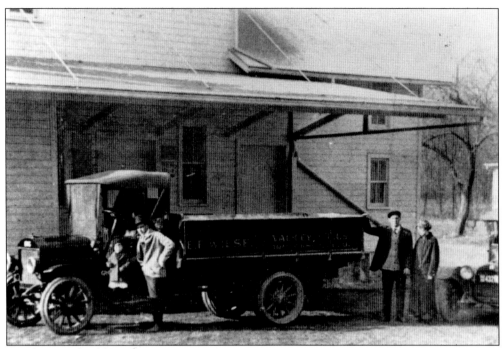

WIESE MILLS TRUCK. Harry Perry left the business in the late 1930s, but Bert Harris continued to run the mill until it was sold to H.B. Larsen in 1947 (at which time flour grinding operations ended). (Courtesy of B.H.A.)

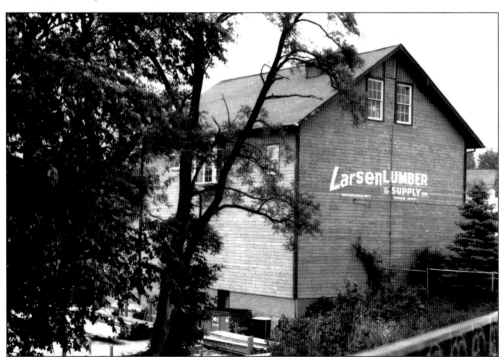

LARSEN LUMBER AND SUPPLY. This business has prospered on the previous site of the Wiese Bros. grist mill since 1947. (Courtesy of B.H.A.)

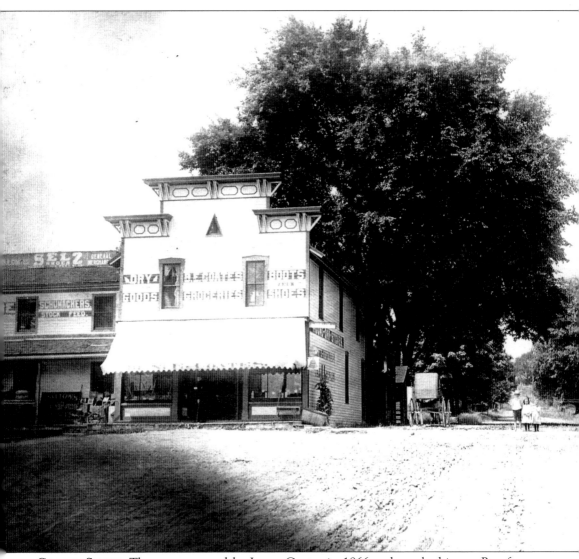

COATES STORE. The store, opened by James Coates in 1866 and run by his son Ben from 1894–1917, was located at what is now Route 82 at Highland Drive. In that era, people not only came downtown to place orders at this and other stores, but also purchased goods from peddlers and door-to-door merchants. For a period of time the Post Office was also located here. (Courtesy of B.H.A.)

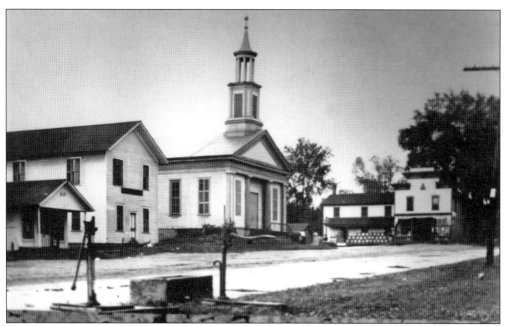

ANOTHER VIEW OF THE COATES STORE. Ben and Harriet Coates, who operated the store (at right in the photograph) for many years, were devoted members of the Congregational Church (center). Harriet's father, Beecher Bell, ran the "hack" carriage that brought passengers and mail between Brecksville Center and the railroad depot. The town water pump is in the foreground in this 19th-century image. (Courtesy of B.H.A.)

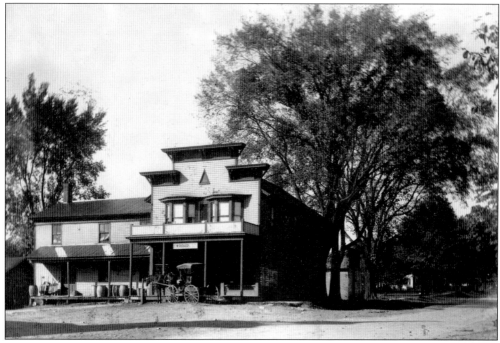

COATES STORE, c. 1910. The store was purchased by Eugene Rudgers in 1917 and was moved in 1936 to Old Royalton Road. (Courtesy of B.H.A.)

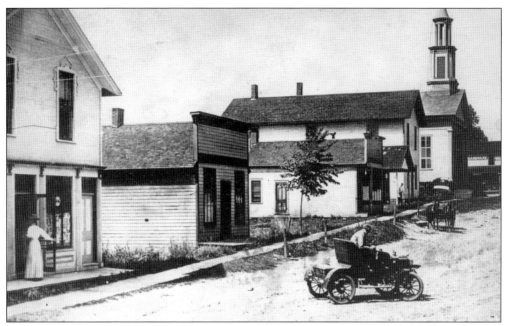

BRECKSVILLE CENTER, c. 1910. The automobile—a solid-tire model, the first to be purchased by anyone in Brecksville—is driven by Al Chavalier, a blacksmith and musician who was well-known locally. The car had been shipped on the railroad to the depot, assembled there, and driven into town. Chavalier also was the first in town to have electric lights. (Courtesy of B.H.A.)

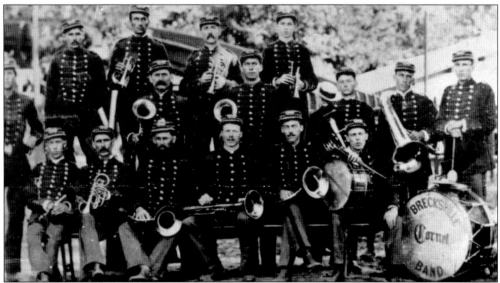

BRECKSVILLE CORNET BAND IN PUBLIC SQUARE, 1882. The band was organized, not long before the photograph was taken, by W.R. Coates (not related to Ben Coates of the Coates Store), a teacher at the Maple Street School. The band played together for ten years. Pictured here are: (in the front row, left to right) Otto Pixley, Herbert Marshall, Frank Marshall, Will Finn, Harvey Adams, and Charles Stone; (in the second row, left to right) Lew Bell, Delos Carter, Frank McCreery, Clark Dillow, John Noble, and Harry Snow; and (in the back row, left to right) Charley Snow, John McCreery, Will Coates, and Theodore Breck. (Courtesy of B.H.A.)

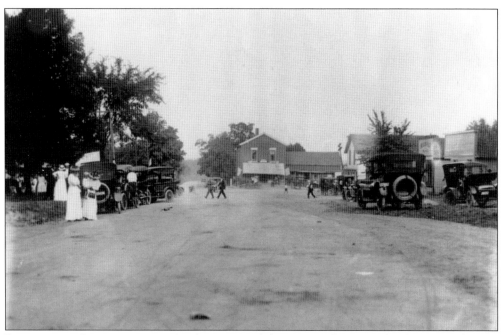

BRECKSVILLE CENTER, 1900S. At the center of this eastward view is the famous Red Brick Store. (Courtesy of B.H.A.)

THE MCCREERYS. Emigrating from Scotland and Ireland and living first on the East Coast, the McCreery family came to Brecksville in 1814 and settled on the southern part of what was later Fitzwater Road, tilling the land by the river. (Courtesy of Jeannette McCreery Eucher Collection.)

The Brick Store
Brecksville, Ohio

(*Left*) BRICK STORE. Built by local builder Chauncey L. Young in 1857, the store changed hands three times before being purchased by David McCreery in 1897. Willis McCreery ran the store from 1901 until his retirement, after which it was rented to other operators (such as "Edwards Foods" in this photograph). (Courtesy of B.H.A.)

(*Right*) BRICK STORE BULLETIN. Having purchased the Brick Store 107 years ago, the McCreery family remarkably still owns the historic structure today. For many years in the 19th century, the second floor of the building was frequently used for oyster suppers (then a popular type of gathering), plays, and other social events. It was commonly referred to as "Barnes Hall." From 1900–1920 the Post Office was located there prior to moving to the Klein Building. (Courtesy of B.H.A.)

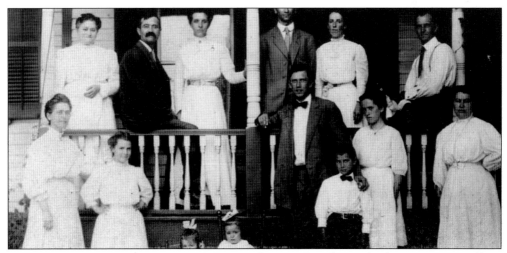

CHRISTMAS GREETINGS FROM THE MCCREERY FAMILY. Deeply involved in community affairs, the Robert Douglas McCreery Sr. family has been one of Brecksville's most prominent families ever since settling in the Village. This photo was taken in 1909. (Courtesy of B.H.A.)

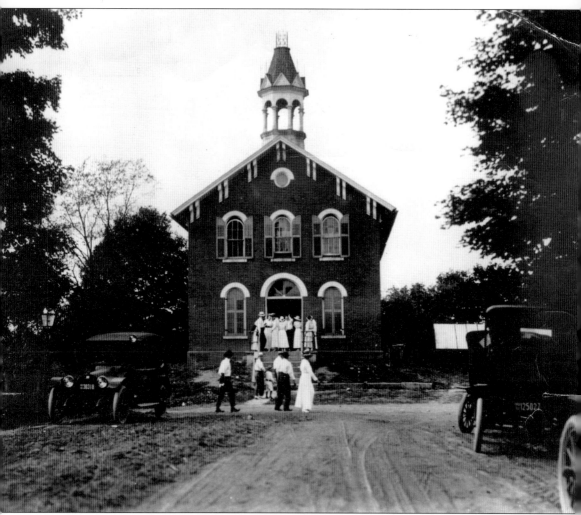

THE OLD TOWN HALL. One of Brecksville's most striking landmarks, the Italianate-style Town Hall was built in about 1870 by Jules White with $3,000 loaned by Emily Moses Wallace. The stone for its foundation was taken from the Chippewa Creek Quarry. (Courtesy of B.H.A.)

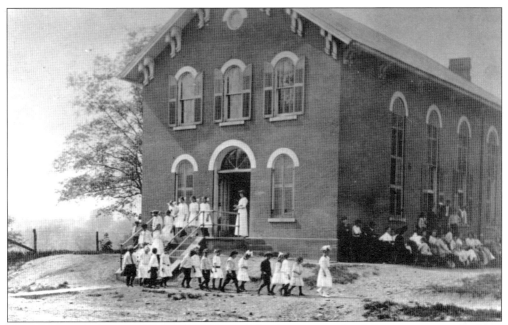

Town Hall, May Day 1915. The classes of the downtown school district were taught there in earlier decades. The children file out as their teacher, Orpha McCreery Snow (who also served as the first president of the Brecksville P.T.A.), watches from the doorway, and their parents sit alongside the building. (Courtesy of B.H.A.)

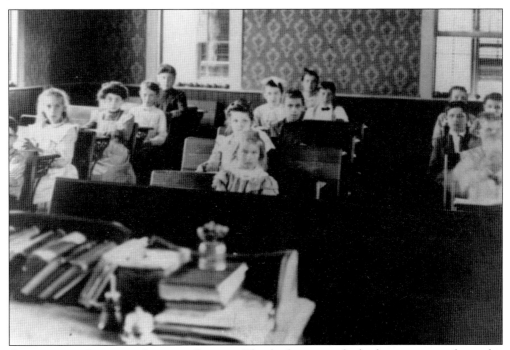

Children in Class at Central School. The final year in which classes were taught in this building on School Street (now Arlington) was 1913–1914. They would be schooled at the Town Hall during 1914–1915, pending the completion of the new Central School. (Courtesy of B.H.A.)

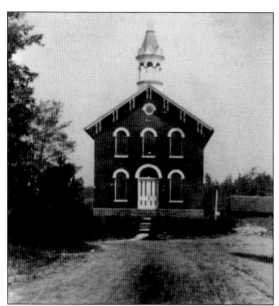

OLD TOWN HALL IN THE HORSE ERA. A stable can be seen to the right of the building. The Brecksville City Council met for many years in the Town Hall's high-ceilinged basement before the new City Hall (a half-mile to the south) was completed in 1972. (Courtesy of B.H.A.)

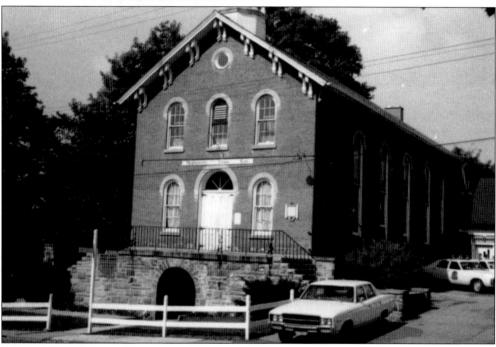

TOWN HALL, 1962. The stage of the venerable old structure has been used for performances of the Brecksville Community Theater and many other events. Each December, a number of traditional holiday attractions are sponsored by the City of Brecksville, most memorably the Children's Christmas Play at the Town Hall, which was begun in 1968 by then-Mayor Jack Hruby. Town Hall has been listed on the National Register of Historic Places since 1973. The assembly hall was destroyed and the roof damaged by a fire in early 1976, but the heroic efforts of Brecksville and Broadview Heights firefighters saved the structure, which was soon rebuilt. After major new renovations in the late 1990s, the building was re-dedicated in August 1998. (Courtesy of Elizabeth B. Hoffman.)

BRECKSVILLE BANK. Local citizen William Urbino Noble (1868–1960) became convinced that the growing Township needed its own bank. He joined with Clark Dillow, Harry McCreery, and a Mr. Cerny from North Royalton and secured backing from the Guardian Bank in Cleveland. Their bank at the center of town opened on September 15, 1919. (Courtesy of B.H.A.)

THE BRECKSVILLE BANK COMPANY, Brecksville, Ohio.

AT THE CLOSE OF BUSINESS, DECEMBER 15, 1921.
BEGAN BUSINESS SEPTEMBER 15, 1919.

RESOURCES		LIABILITIES	
Loans and Discounts	$161,909.98	Capital Stock	$ 25,000.00
State, County and Municipal		Surplus & Undivided Profits	3,000.00
Bonds	51,449.25	Undivided Profits Reserved	
Banking House and Lot	9,969.45	for Interest, Jan. 1	1,103.72
Furniture and Fixtures	2,810.10	Savings Deposits $144,773.49	
Cash on Hand...$ 3,715.37		Cashier's Checks. 1,192.92	
Due from Reserve Bank ... 19,583.73		Individual Deposits Subject to Check 74,247.75	
Total Cash Reserve	23,299.10	Certified Checks. 120.00	
		Total Deposits	220,334.16
Total Resources	$249,437.88	Total Liabilities	$249,437.88

W. U. Noble, Pres. R. Luther, Vice Pres. Lindsay Wharton, Cashier.

Directors:

A. S. Buskirk	C. J. Dillow	W. H. McCreery	Willis Rice
E. C. Cerny	G. S. Fitzwater	Ben Metzger	Harry W. Snow
A. L. Chavalier	R. Luther	W. U. Noble	Edw. Vyrostek

W. N. Weld

BRECKSVILLE BANK ARTIFACT. The bank joined the Federal Reserve system in 1934. William Noble remained president until his retirement in 1950. (Courtesy of B.H.A.)

41

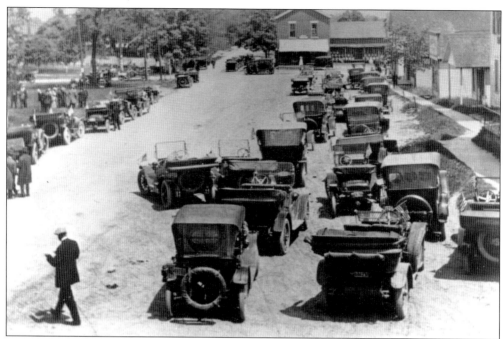

TRAFFIC JAM. This image comes from the 1920s, but its effect has been replicated countless times since during rush hours in busy Brecksville Center. (Courtesy of B.H.A.)

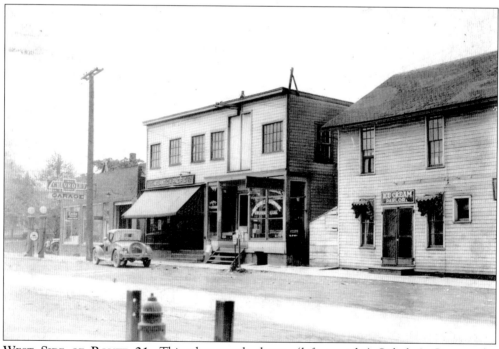

WEST SIDE OF ROUTE 21. This photograph shows: (left to right) Sithelm's Garage, the Atlantic & Pacific Tea Company, the Brecksville Hardware (owned by Al Chavalier), and the Ice Cream Parlor. The widening of Brecksville Road in 1928–1930 eliminated Sithelm's Garage and other buildings on this side of the street. (Courtesy of B.H.A.)

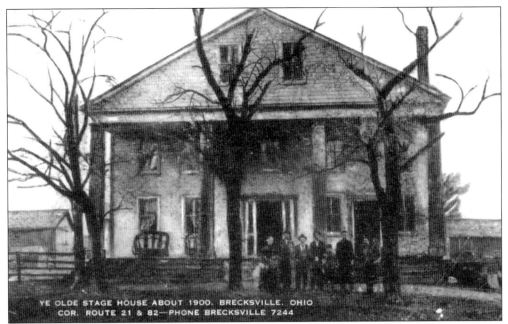

YE OLDE STAGE HOUSE ABOUT 1900, BRECKSVILLE, OHIO
COR. ROUTE 21 & 82—PHONE BRECKSVILLE 7244

THE STAGE HOUSE. This building at the intersections of Routes 21 and 82, built in 1839 to a Greek Revival design by Oric and Austin Edgerton, began life as the Brecksville Inn. Ten years later it was converted to a stage house to serve as a stop along the stagecoach line. A popular gathering place for locals, the structure boasted walls made of five-inch-thick black walnut. (Courtesy of B.H.A.)

BRECKSVILLE ROAD c. 1900 IN FRONT OF THE STAGE HOUSE (THE BRECKSVILLE HOTEL). The poor condition of the main roads into Brecksville was the very thing that preserved its rural lifestyle for so long. Originally a Native American trail, Ohio Route 21 was surveyed from Cleveland all the way south to Wooster by 1827. Two years later, the road itself had been laid through Brecksville to Richfield. With its up-and-down profile due to the crossing of many ravines, 21 was then called "The Devil's Washboard." The road was first hard-surfaced in 1890. (Courtesy of B.H.A.)

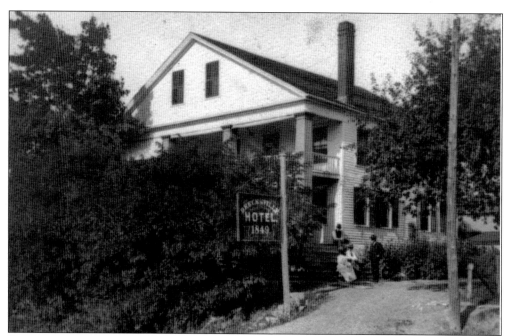

STAGE HOUSE, c. 1930. At this time, the Stage House was called the Brecksville Hotel (it had previously been called the Chippewa Hotel). The structure underwent so many additions and remodelings in its various incarnations over the years that its original form was no longer recognizable. In 1941, Joseph Flanagan bought the building from the C.O. Bartlett Estate, remodeling it again and opening it as "Ye Olde Stage House." Flanagan's restaurant was renowned for its tasty menu. (Courtesy of B.H.A.)

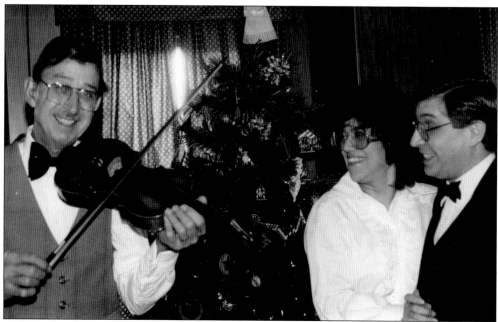

CHRISTMAS FIDDLING. Charlie Hagan plays the violin at a holiday function inside Ye Olde Stage House. (Courtesy of B.H.A.)

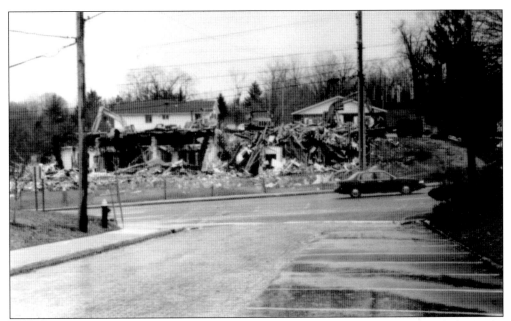

OLD STAGE HOUSE BEING DEMOLISHED, NEW YEARS EVE 1999. By this time the structure was considered to be irreparable, and the decision was made to raze it and construct a new building in the spirit of the old one. The sign from the old building was saved by Mike Cushman, the Terra Group's demolition foreman, and brought to the Brecksville Historical Association for preservation. (Courtesy of B.H.A.)

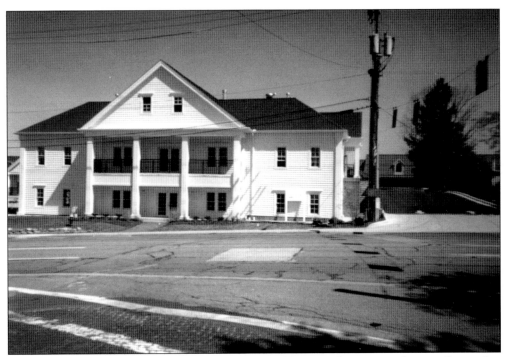

NEW STAGE HOUSE. The 8,000-square-foot Stage House replica is seen here in September 2002. It now contains professional offices. (Courtesy of B.H.A.)

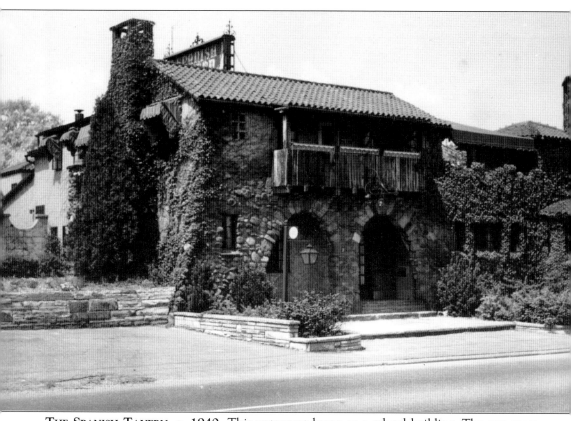

THE SPANISH TAVERN, c. 1940. This restaurant began as a school building. The one-room District No. 6 schoolhouse, located on Fitzwater Road, was sold in 1910 to Tom Svoboda when the schools were consolidated into one central location. Svoboda had the building hauled to the intersection of Fitzwater and Brecksville Roads, and opened Svoboda's General Store. Travelers along the muddy, dirty (and often flooded) Brecksville Road stopped at the store for refreshment. In 1924, the store along with the lot and building next door were acquired by George Stark, who added a dance hall to the back of the structure and opened Springdale Dance Hall. When work began on the widening and paving of Brecksville Road in 1928, Stark had to tear down the storefront and close the hall. He rebuilt and reopened the restaurant with bright Spanish decor, a stone fireplace, and chestnut beams and furniture hand-carved by Stark, and it began attracting a devoted clientele. After attracting patrons from a wide area for decades, the restaurant was sold in 1993 and renamed Marco Polo, but it closed in 2003. The Spanish Tavern is much missed. (Courtesy of B.H.A.)

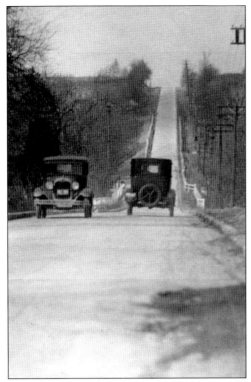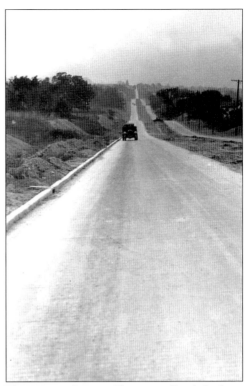

(*Left*) **BRECKSVILLE ROAD, MARCH 21, 1930.** This view, taken at Chippewa Creek looking north, shows the 18-foot roadway of Ohio Route 21 before it was widened to 40 feet. (*Cleveland Press*, courtesy of Special Collections, Cleveland State University.)

(*Right*) **BRECKSVILLE ROAD, OCTOBER 1930.** Here, widening of the road to separate brick-paved lanes is in progress. (*Cleveland Press*, courtesy of Special Collections, Cleveland State University.)

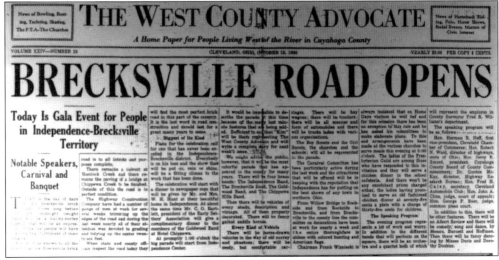

NEWSPAPER HEADLINE, OCTOBER 18, 1930. Development in the Village would accelerate after the completion of road improvements. (Courtesy of B.H.A.)

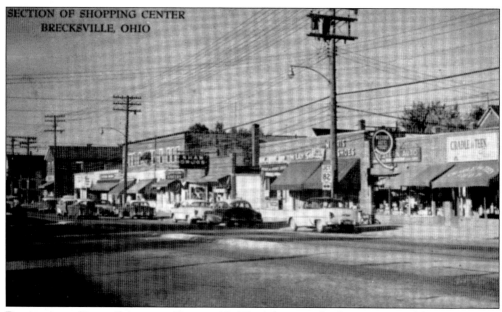

BRECKSVILLE ROAD SOUTH OF ROUTE 82. This photograph, showing several businesses that are long gone today, dates from the 1950s. (Courtesy of Jerry N. Hruby.)

LOOKING NORTH TOWARD BRECKSVILLE ON ROUTE 21, OCTOBER 1964. Paving over the bricks sped up the pace of development even more. (*Cleveland Press*, courtesy of Special Collections, Cleveland State University.)

BRECKSVILLE UNITED METHODIST SOCIETY CHURCH C. 1905. This congregation was organized in 1814 in the log cabin of Lemuel Bourne with a missionary presiding. In 1823, the 16-member group formed the Brecksville Methodist Society. Construction of the church seen here was begun in 1832 and completed in 1840. For many years, there was no bell in the belfry due to the high cost of freight before the arrival of the Valley Railroad. In 1905, the trustees decided to purchase a bell that would harmonize with the tone of the bell in the Congregational Church. The bell was made at the Buckeye Bell Foundry in Cincinnati. When it arrived, it proved to be too large for the belfry, and extensive remodeling was required. (Courtesy of B.H.A.)

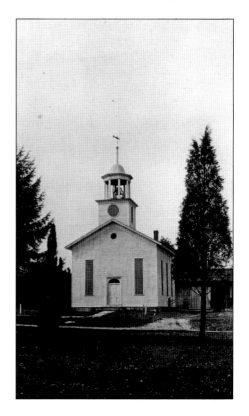

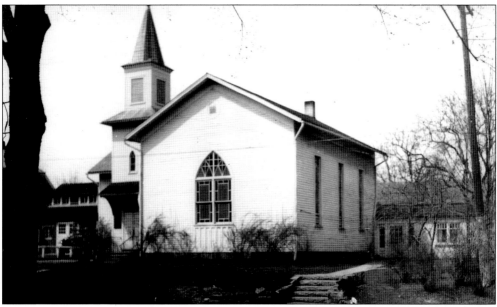

BRECKSVILLE UNITED METHODIST CHURCH. The 1909 remodeling project included a new tower entrance and steeple, and a room to serve as a classroom and dining room. While awaiting construction of a new building in 1960 (see bottom photograph on p. 52), the congregation held services at the Old Town Hall. (Courtesy of B.H.A.)

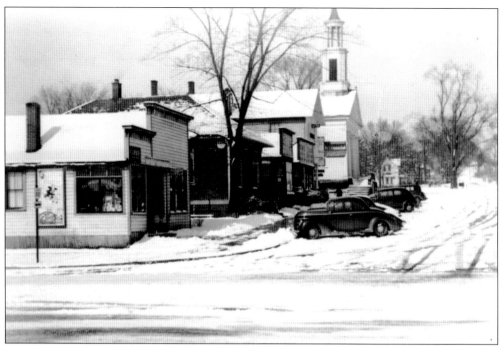

DOWNTOWN VIEW IN WINTER, C. 1930S. The corner building housed Reed's Soda Bar & Grill, a popular high school hangout in the early 1950s. Later in the decade, it would be razed and a bank building erected on the site. (Courtesy of the Estate of Ruby C. Carroll.)

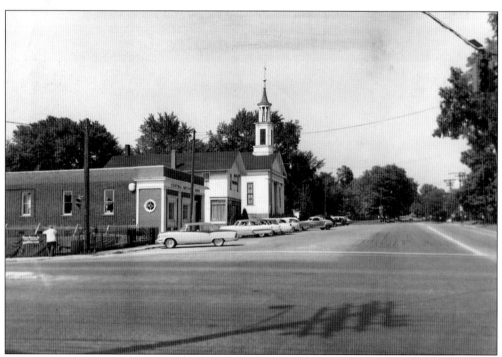

THE SAME VIEW, AUGUST 1957. Much has changed indeed over two decades. (*Cleveland Press*, courtesy of Special Collections, Cleveland State University.)

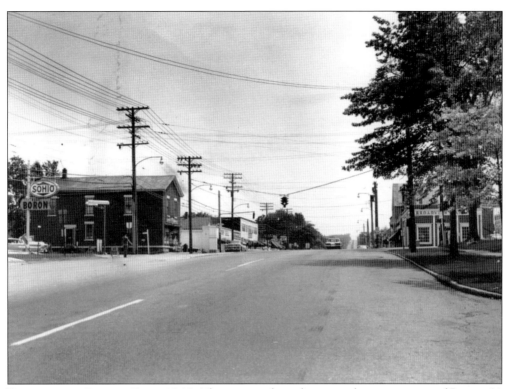

BRECKSVILLE CENTER, JUNE 1960. This is a southward view at the intersection of Routes 21 and 82. The first traffic light in town had been installed here 30 years earlier. (*Cleveland Press,* courtesy of Special Collections, Cleveland State University.)

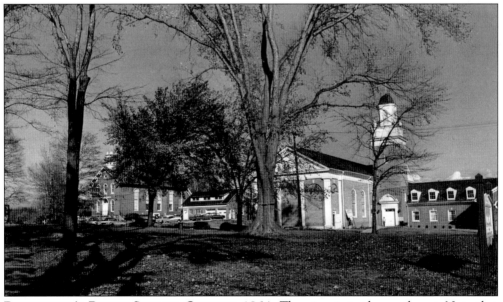

BRECKSVILLE'S PUBLIC SQUARE, OCTOBER 1964. The view is to the northwest. Note that the gazebo (see page 53) is missing from the Square. (*Cleveland Press,* courtesy of Special Collections, Cleveland State University.)

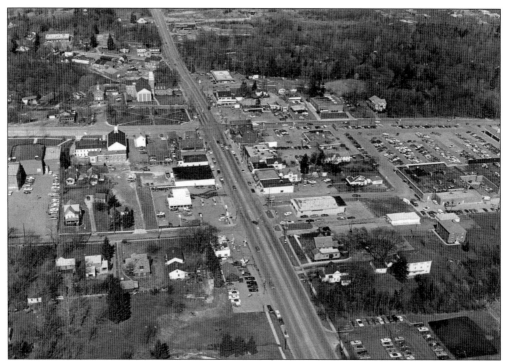

AERIAL VIEW OF BRECKSVILLE, MARCH 1973. That Brecksville had become a city is evident from the growth seen here. (*Cleveland Press*, courtesy of Special Collections, Cleveland State University.)

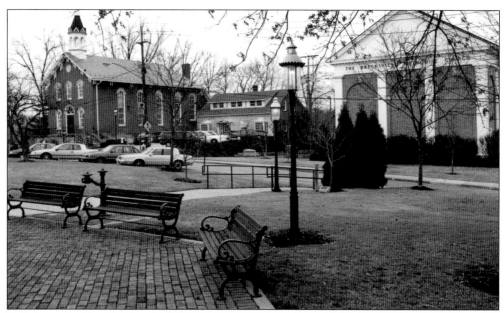

BRECKSVILLE SQUARE IN THE MODERN ERA. The architectural styles of the Old Town Hall, the Methodist Church, and the annex originally built to house the Fire Department (now occupied by the Brecksville Department of Human Services and the Senior Center) blend nicely. (Courtesy of B.H.A.)

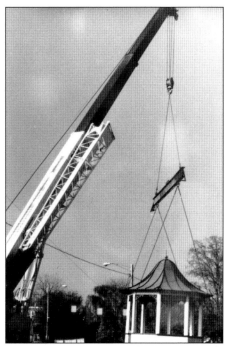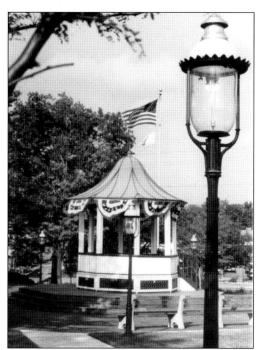

(*Left*) THE GAZEBO'S RETURN TO THE SQUARE, JUNE 27, 1980. This beloved Brecksville landmark had been removed from the Square to a private residence in the late 1920s and replaced with a two-story refreshment area and bandstand. In the 1970s, a group of citizens with the assistance of the Chamber of Commerce restored the Gazebo and relocated it to Public Square. (Courtesy of B.H.A.)

(*Right*) THE GAZEBO WITH PATRIOTIC TRIMMINGS. As part of a tribute to the late Mayor Jack Hruby, in the late 1980s the Square was renovated (with additional restoration to the Gazebo) and rededicated, along with the Clock and Bulletin Board, in his memory. (Courtesy of B.H.A.)

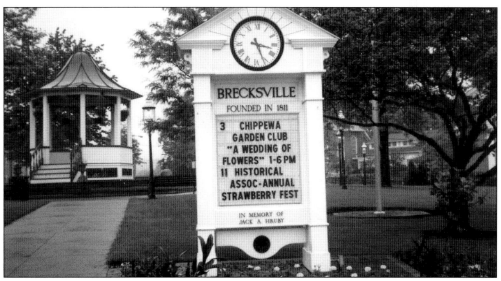

BRECKSVILLE GAZEBO. The sign was dedicated to the memory of Jack Hruby, Brecksville's mayor from 1970–1986. More on Mr. Hruby may be found on page 62. (Courtesy of B.H.A.)

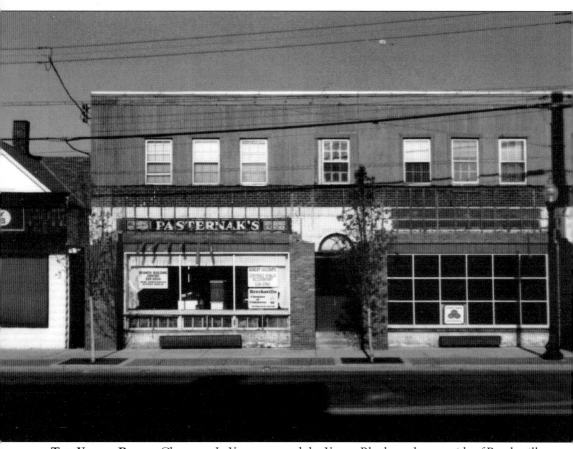

THE YOUNG BLOCK. Chauncey L. Young erected the Young Block on the east side of Brecksville Road while it was being widened in 1928–1930. One of the occupants in this two-story building was Pasternak's Dry Goods Store. Dr. Vigor, M.D. and Dr. Vosatka, D.D.S. had offices on the second floor, which in later years were apartments. Young erected the Brick Store in 1857 and operated it for a number of years. He owned a great deal of real estate, as well as businesses including a sawmill, a restaurant, and a garage. (Courtesy of B.H.A.)

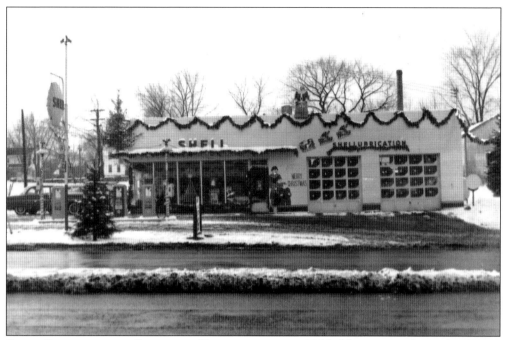

SHELL STATION WITH CHRISTMAS DECORATIONS, c. 1955. The station, located at Route 21 and Arlington, was first built with concrete blocks, and the more attractive porcelain covering was added in 1954. (Courtesy of Wally Zimlich.)

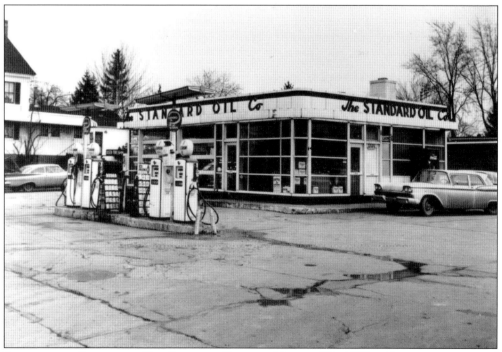

BRECKSVILLE STANDARD OIL STATION, ROUTES 21 AND 82, 1950s. Vintage gas pumps of this type are highly prized at auctions today! (Courtesy of B.H.A.)

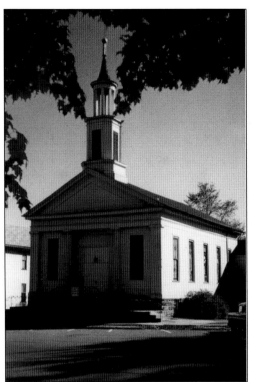

BRECKSVILLE CONGREGATIONAL CHURCH. This church in Brecksville Center, built in approximately 1844 as the Brecksville Presbyterian Church with 13 members, was one of the city's most revered landmarks. During 1841–1844, funds were raised from the sale of pews (the front pews bringing $100 and those in the center of the church, $50) for a building project. In 1854, it became an independent Congregational Church. The bell was given in fulfillment of a promise made by the Breck family to donate a bell to the first church to be completed in Brecksville. There were 90 members in the congregation when the church was dedicated. In 1962, the Congregational Church officially became part of the United Church of Christ. (Courtesy of B.H.A.)

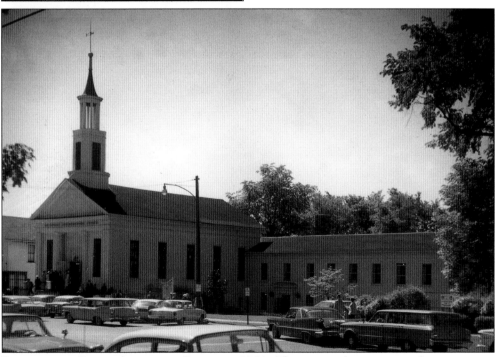

BRECKSVILLE CONGREGATIONAL CHURCH, 1961. This image shows a new classroom wing that had been added to the church in 1953, along with a remodeling of the chapel and parlor. (Courtesy of B.H.A.)

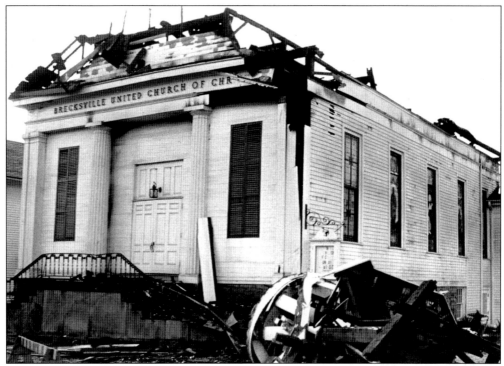

ARSON STRIKES THE UNITED CHURCH OF CHRIST. On November 20, 1965, the church burned with the devastating effects seen here. The bell tower (foreground) fell during the fire, its heavy cast iron bell coming close to firefighters and onlookers as it crashed down. The fire caused $150,000 worth of damage. (*Cleveland Press*, courtesy of Special Collections, Cleveland State University.)

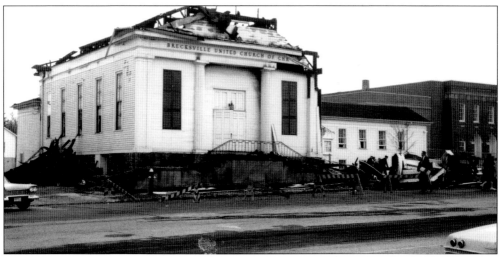

ANOTHER VIEW OF THE CHURCH AFTER THE FIRE. It turned out that the fire had been set to cause a diversion, so that thieves could break into nearby clothing stores and make off with over $14,000 in merchandise. It took nearly a decade for the culprits to be brought to trial. The church was rebuilt at a cost of $300,000, and the large Ellenberger Memorial Organ—suitable not just for church services but also for recitals—was installed in 1969. (Courtesy of B.H.A.)

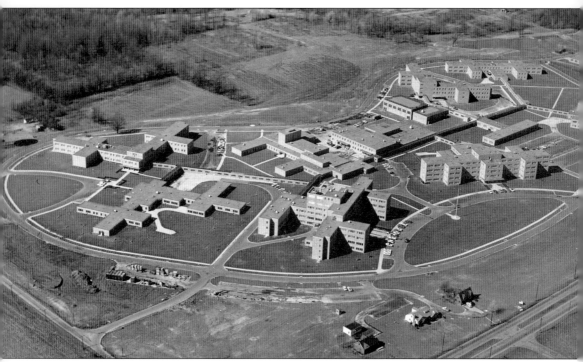

VETERANS ADMINISTRATION HOSPITAL COMPLEX. This photograph shows the newly-built $23 million facility devoted to veterans requiring psychiatric treatment, which was dedicated on September 17, 1961. This hospital was built to complement the Brecksville U.S. General Medical Facility located in Broadview Heights four miles to the west. (Courtesy of B.H.A.)

Three

GOVERNMENT, POLITICS, AND BUSINESS

Brecksville was incorporated as a village in 1922. In December of 1921, City Council and Mayor Bert Harris had met for the first time to organize their new village government. Some property owners who had not agreed to become part of the Village remained a township until 1927, when Broadview Heights was incorporated. Ohio Bell opened a new building at 7301 Chippewa Road and installed dial service to replace the old party-line operator service, which had been run out of a house. For financial reasons the Village of Brecksville and the Township including Broadview Heights maintained a joint school district. One of the main reasons for the split between the Township and the Village was the matter of taxation for the financing of electricity and water (which was one of the first tasks facing the new Village along with the formation of its government). The mayor and a six-member council, as promised, brought electricity during the 1920s and water in 1932.

Brecksville's growth from a quiet farming community into a vibrant commuter city would now bring significant challenges to city government and services. For decades there was no organized firefighting, for instance; citizens helped each other fight house or business fires with whatever was on hand. Small schoolhouses served isolated districts spread around the town, until the day came when consolidation into a central school district was a necessity. The police force expanded in response to population growth and ever-increasing traffic.

While standing in line in the modern and efficient Post Office today, it is worth remembering that when mail service was instituted in 1827 under Postmaster Thomas Allen, one delivery per week reached town, and a letter cost more, in unadjusted price per envelope, than it does today! Later on, the Post Office was set up in the Coates store, and three mails per week arrived; in 1900, the Brick Store began to handle the mail with David McCreery as Postmaster, later succeeded by his daughter Myrtle.

The Good Templars Lodge started a small library in the Old Stone House on the site of the present Town Hall. The house was razed, and the library moved to the Cheese House at 8913 Brecksville Road, then to the basement of the Presbyterian Church. In its early days, the I.O.O.F. (Odd Fellows) Lodge had books. In 1881, the High School started a library. Local fundraising was supplemented by a special law through the Ohio legislature that permitted the town to put a one-mill levy on real estate for library support. This was continued until the library became a part of the Cuyahoga County Public Library system on March 10, 1926, with Mrs. Mary C. Bourn as its first county branch librarian. The library was a roamer in early days, with quarters in a small room off a kitchen, an upstairs hallway in the Brick Store, the Methodist parsonage, and the home of Mrs. Ernest Bourn. On October 21, 1990, the well-traveled collection was dedicated in its proud new home at 9089 Brecksville Road.

Today the Brecksville-Broadview Heights City School District (ranked in the top ten percent of districts nationwide) serves approximately 4,735 students. The schools have made quite a journey from the one-room schoolhouses of a century ago.

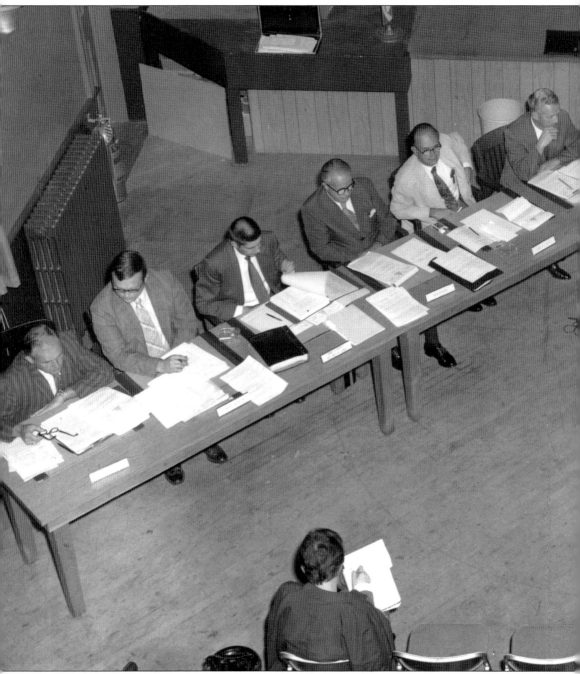

BRECKSVILLE CITY COUNCIL IN SESSION. The current structure of Brecksville government was laid down on November 6, 1956, when its charter was first adopted (four years before city status was achieved). Government is headed by the mayor and a seven-member elected City Council. A charter Review Commission is appointed by Council to review and amend the charter once per decade, their recommendations subject to a vote of citizens. The mayor (who is also the Safety Director), elected to a four-year term, appoints most of the city department directors (the Clerk of Council and the Directors of Finance and Law are appointed by the City Council) and

oversees law enforcement and the execution of all city contracts. This photograph was taken in the old Town Hall on September 21, 1971, not long before the Council moved to the new City Hall. Seated here, from left to right, are: Carl J. Vogt, Robert Jaite Jr., Vice President Roger H. Hippsley, Ben Bugeda, Lowell P. Skeel, Kenneth N. Gottschalk, President Ralph Biggs, Clerk Ada Carter, Mayor Jack Hruby, Law Director Earl Longley, and Building Commissioner Harry Jelinek. (Courtesy of B.H.A.)

BRECKSVILLE'S NEW CITY HALL UNDER CONSTRUCTION. The move from the old Town Hall brought modernized facilities for city government and freed up space at the older building for the arts and special events. (Courtesy of B.H.A.)

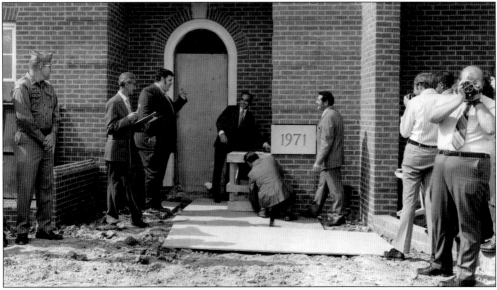

DEDICATION OF BRECKSVILLE CITY HALL, 1972. Mayor Jack Hruby is third from left, and Dr. Frank Vosatka (then President of the Brecksville Historical Association) is second from left. Mayor Hruby was a beloved leader of the City. When only 18, he became a Cuyahoga County Deputy Auditor. He was elected to Council of the City of Brecksville at just 22 in 1968 and was sworn in as Mayor two years later, following the early death of Mayor Gourley. Mayor Hruby was a great supporter of the Brecksville Fire Department—once even rescuing a man from a house fire himself during his term of office—and he made it his mission to create a full-time Fire Department. He was also a musician who played at many local functions, an actor with Theatre on the Square, and an enthusiastic Santa Claus for Brecksville children. Jack Hruby continued to serve as Mayor of Brecksville until his untimely death in December 1986. (Courtesy of B.H.A.)

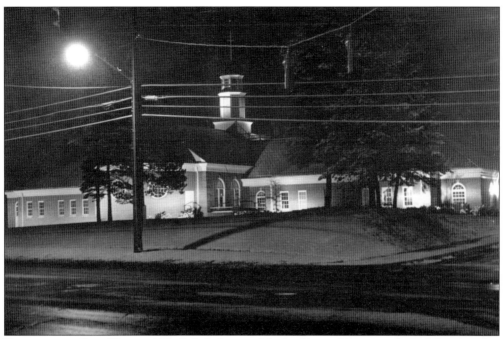

BRECKSVILLE CITY HALL, 1973. Side lighting of the building adds a great deal of charm to this night view. (Courtesy of Jerry N. Hruby.)

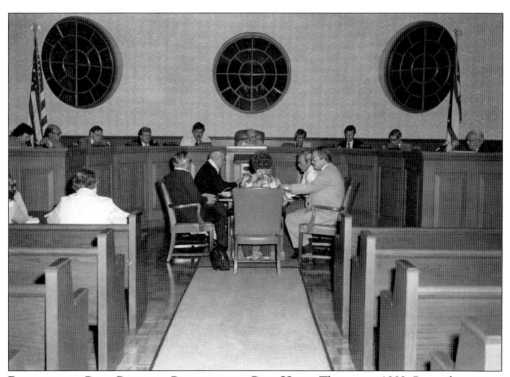

BRECKSVILLE CITY COUNCIL CHAMBERS IN CITY HALL. This was a 1982 Council meeting. (Dorcas Snow Collection, courtesy of B.H.A.)

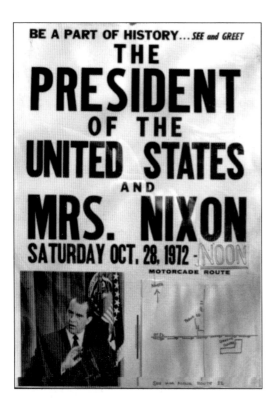

BE A PART OF HISTORY...SEE and GREET

THE PRESIDENT
OF THE
UNITED STATES
AND
MRS. NIXON
SATURDAY OCT. 28, 1972 - NOON
MOTORCADE ROUTE

PRESIDENT NIXON COMES TO BRECKSVILLE. The visit came at a very late stage of the 1972 campaign, in which Nixon defeated George McGovern in a landslide. (Courtesy of B.H.A.)

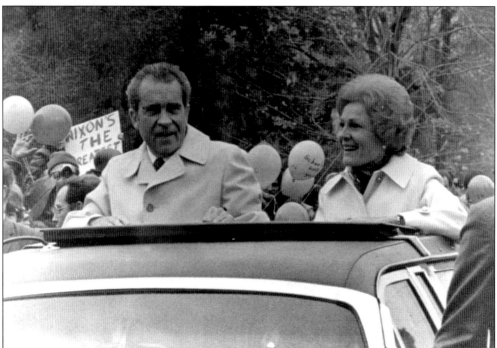

THE FIRST COUPLE. President Richard Nixon and his wife Pat enjoy a ride in and open car. That the Secret Service would allow them to ride in such a manner was remarkable in view of the Kennedy assassination, not yet a decade past. (Courtesy of B.H.A.)

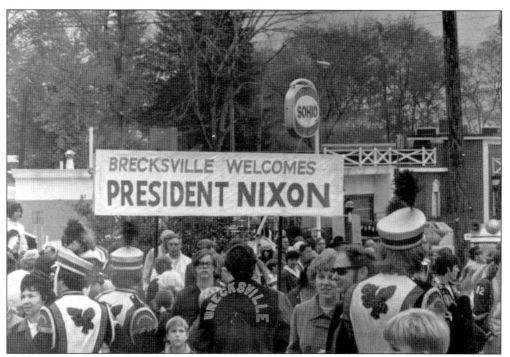

NIXON IN BRECKSVILLE. Members of the Brecksville High School Band, which played at the campaign appearance, mingle with the crowd. (Courtesy of B.H.A.)

REDEDICATION OF CITY COUNCIL CHAMBERS. For the 25th anniversary celebration of City Hall on this site, Council Chambers was renamed "Ralph Biggs City Council Chambers" to honor the memory of the past president who had served 25 years on the Council. (Courtesy of B.H.A.)

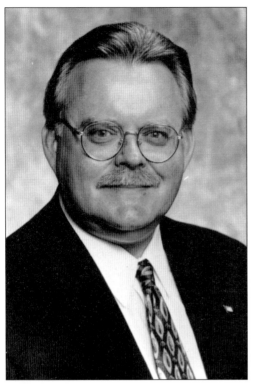

MAYOR JERRY N. HRUBY. The Hruby family has served the citizens of Brecksville for many years. Mayor Jerry Hruby is the brother of the late Mayor Jack Hruby; indeed, just over 12 months separate their tenures in office. Jerry, a lifelong resident of Brecksville, graduated from Brecksville High School in 1966. He began serving part-time with the Brecksville Police Department in 1968 while going to Kent State University and had advanced to Detective Lieutenant when he decided to run for mayor in 1987. Elected by a solid margin, he began his first term in 1988. Mayor Hruby was elected to his fifth term as Mayor in November 2003 and is as much admired in that post as his brother Jack had been. Mayor Jerry N. Hruby described his brother's way of governing and leading the community as "building its future with respect for its past." This became the slogan of Jerry Hruby's campaign for mayor and his administration and also became the motto of the community along with its much older slogan, "A Community of the Western Reserve." (Courtesy of B.H.A.)

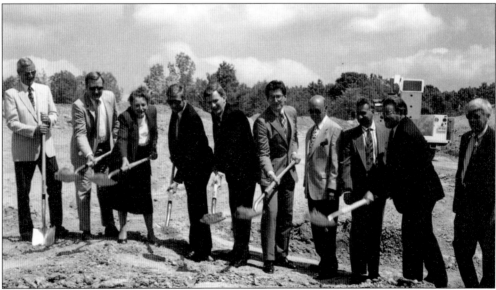

TURNING A CEREMONIAL SHOVEL. Mayor Jerry Hruby (second from right) and members of the City Council break ground for the new Brecksville Community Center. The 48,000-square-foot Community Center that opened in 1992, with its distinctive clock tower, has extensive state-of-the-art facilities including the Jack A. Hruby Natatorium, an outdoor pool, walking and jogging tracks, basketball and volleyball courts, a batting cage, a weight and fitness room, saunas and a whirlpool, as well as a day care facility and youth game room. Its community room is served by a well-equipped kitchen, and there is a stage for public events. (Courtesy of B.H.A.)

MODERN CITY FACILITIES. For all but one year of the past 34, the City of Brecksville has had one of the Hruby brothers as mayor. During that time a new City Hall and City Complex were constructed, including a new County Library, City Community Center and Recreation Facility, Kids Quarters, Municipal Lake, Recycling Center, city-owned satellite Postal Unit, and the RTA Park 'n' Ride/City Parking Lot. (Courtesy of B.H.A.)

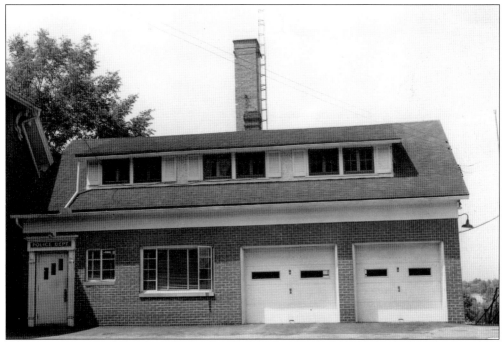

POLICE STATION, 1961. Originally built for the Fire Department, the annex became home to the Police Department in 1961 when the new fire station was put into service (see page 68). (Courtesy of B.H.A.)

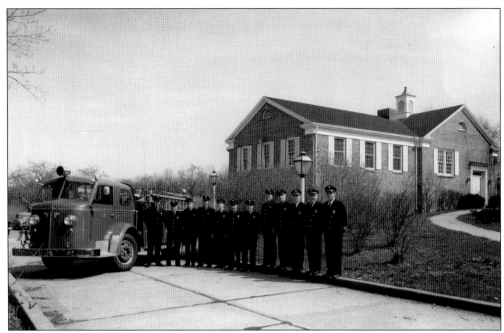

BRECKSVILLE FIRE DEPARTMENT, 1962. The Fire Department, like the police force, has grown with changing times since it was first organized in 1928. The bond for the construction of this new fire station at 9023 Brecksville Road was passed by the Council in 1952. In 2002, ground was broken for a significant expansion of the building. Two new wings were added to create space for training and for two large equipment bays. (Courtesy of B.H.A.)

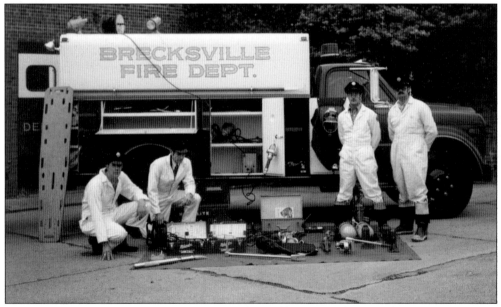

BRECKSVILLE FIREFIGHTERS, EARLY 1970S. Pictured here, from left to right, are: Tom Fowler, Max Buban, Greg Hutchinson, and Dennis Kancler. Hutchinson was treated for smoke inhalation after he and other firefighters fought successfully to save the old Town Hall from destruction in 1976. (Courtesy of B.H.A.)

BRECKSVILLE POLICE DEPARTMENT HOLIDAY CARD, 1966. One of Brecksville's selling points for home buyers has been its historically low crime rate—the benefit of a Police Department known for its quick response time. Having grown steadily over the years to meet the needs of Brecksville's increasing population and tourist traffic, the force boasted 31 full-time officers by 2003. (Courtesy of Bev Clark.)

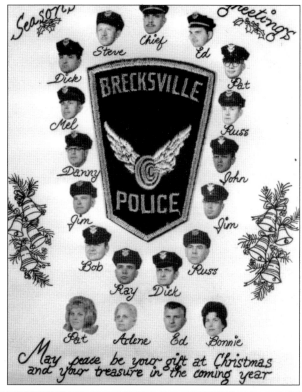

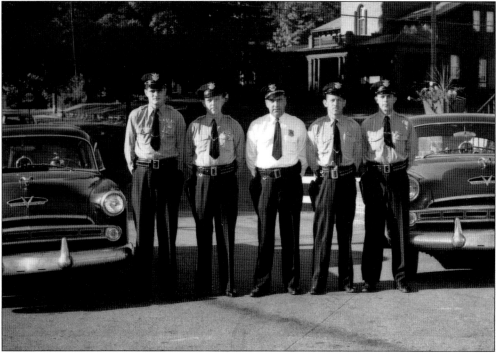

BRECKSVILLE POLICE FORCE IN 1953. They are, from left to right, Joe Roth, Frank Rataczak, Chief William Senkbeil, Steve Puttera, and Mel Pay. (Courtesy of Bev Clark.)

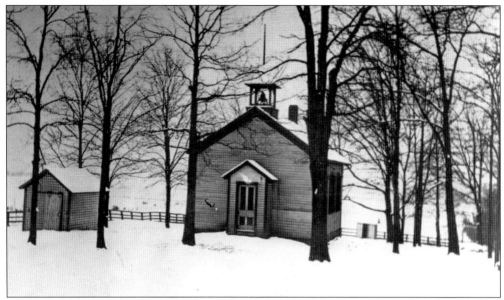

MORGAN SCHOOL, DISTRICT NO. 9. Built in about 1861 on a half-acre of land along Wallings Road donated by the Breck family, the school operated from the 1870s until 1919; but Brecksville school history goes back much further, to the very beginnings of the Township. According to Theodore Breck (son of Colonel John Breck), the first log schoolhouse in Brecksville had been established by Miss Oriana Paine, the youngest daughter of Seth, in 1815. (Students could board there for $1 per week.) The following year, a frame building for a schoolhouse was erected on the future site of the Coates Store. (Courtesy of B.H.A.)

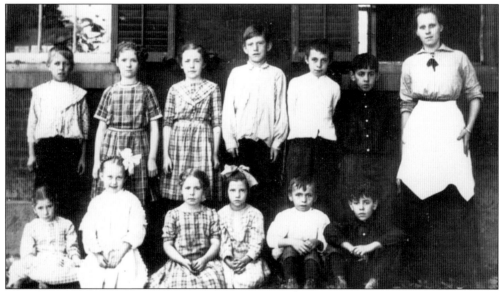

MAPLE STREET SCHOOL, c. 1910. This building, one of four stone schools in the township, was one of several separate schoolhouses that served the far-flung districts of Brecksville. In 1919, the students were moved to Brecksville Center for their schooling, and the property was sold to the Rickmers family, who built a house on it. This land would ultimately become the site of the B.F. Goodrich Research Center. (Courtesy of B.H.A.)

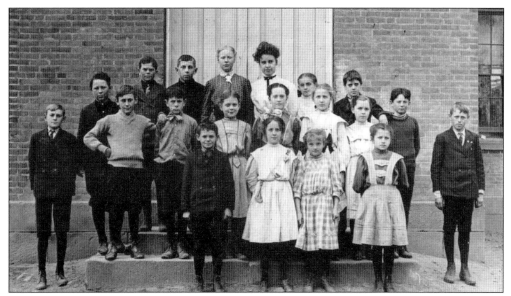

GRAMMAR SCHOOL STUDENTS, 1908. At this time there were nine school districts in Brecksville, each accommodating grades one through twelve within a one-room building. (Courtesy of B.H.A.)

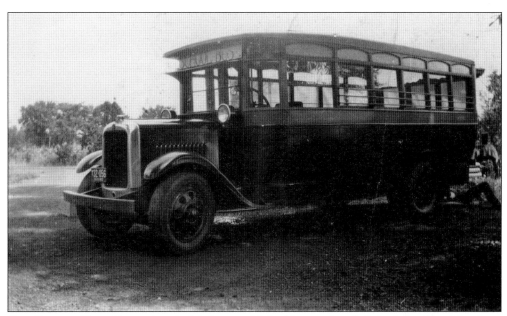

OLD SCHOOL BUS. On weekends this bus would double as a shuttle bringing golf caddies from Cleveland to Sleepy Hollow Country Club. (Courtesy of Meredith Bourne Giere.)

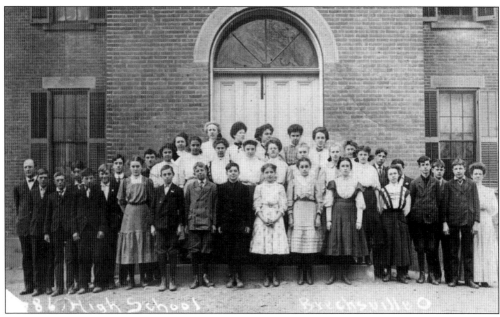

BRECKSVILLE HIGH SCHOOL STUDENTS. This postcard is postmarked 1908. The public high school had been established in the fall of 1882 with T.D. Oviatt as teacher. (Courtesy of B.H.A.)

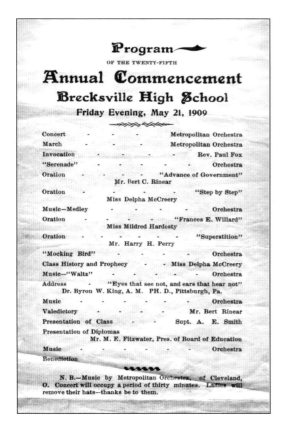

Program

OF THE TWENTY-FIFTH

Annual Commencement

Brecksville High School

Friday Evening, May 21, 1909

Concert	- - -	Metropolitan Orchestra
March	- - -	Metropolitan Orchestra
Invocation	- - -	Rev. Paul Fox
"Serenade"	- - -	Orchestra
Oration	- - -	"Advance of Government"
	Mr. Bert C. Rinear	
Oration	- - -	"Step by Step"
	Miss Delpha McCreery	
Music—Medley	- - -	Orchestra
Oration	- - -	"Frances E. Willard"
	Miss Mildred Hardesty	
Oration	- - -	"Superstition"
	Mr. Harry H. Perry	
"Mocking Bird"	- - -	Orchestra
Class History and Prophecy	- -	Miss Delpha McCreery
Music—"Waltz"	- - -	Orchestra
Address	"Eyes that see not, and ears that hear not"	
	Dr. Byron W. King, A. M. PH. D., Pittsburgh, Pa.	
Music	- - -	Orchestra
Valedictory	- - -	Mr. Bert Rinear
Presentation of Class	- -	Supt. A. E. Smith
Presentation of Diplomas		
	Mr. M. E. Fitzwater, Pres. of Board of Education	
Music	- - -	Orchestra
Benediction		

N. B.—Music by Metropolitan Orchestra, of Cleveland, O. Concert will occupy a period of thirty minutes. Ladies will remove their hats—thanks be to them.

BRECKSVILLE HIGH SCHOOL COMMENCEMENT, 1909. To judge by everything listed on the program, this ceremony was a marathon event to rival a Wagner opera. Maybe attention spans *were* longer then! (Courtesy of B.H.A.)

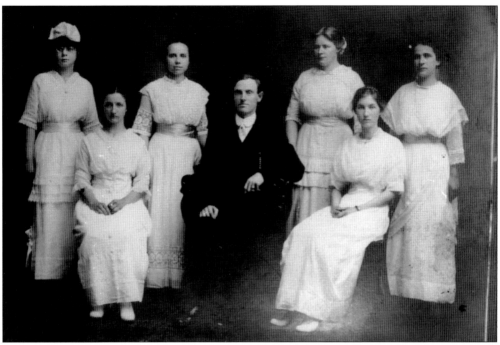

BRECKSVILLE HIGH SCHOOL CLASS OF 1914. Consolidation into fewer and larger schools would soon be underway. (Courtesy of B.H.A.)

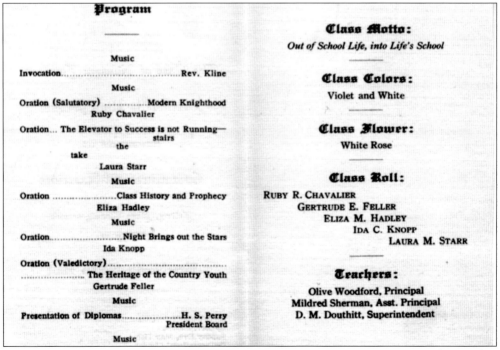

Program

Music

Invocation.................................Rev. Kline

Music

Oration (Salutatory)Modern Knighthood
Ruby Chavalier

Oration... The Elevator to Success is not Running—
 stairs
 the
 take
 Laura Starr

Music

OrationClass History and Prophecy
Eliza Hadley

Music

Oration.......................Night Brings out the Stars
Ida Knopp

Oration (Valedictory)..
..................... The Heritage of the Country Youth
Gertrude Feller

Music

Presentation of Diplomas.................H. S. Perry
President Board

Music

Class Motto:

Out of School Life, into Life's School

Class Colors:

Violet and White

Class Flower:

White Rose

Class Roll:

RUBY R. CHAVALIER
GERTRUDE E. FELLER
ELIZA M. HADLEY
IDA C. KNOPP
LAURA M. STARR

Teachers:

Olive Woodford, Principal
Mildred Sherman, Asst. Principal
D. M. Douthitt, Superintendent

BRECKSVILLE HIGH SCHOOL COMMENCEMENT PROGRAM. The ceremony occurred on Friday, May 22, 1914. (Courtesy of B.H.A.)

APPEALING TO THE POPULAR TASTES. These Chorus members sang in an operetta at Brecksville High School in 1930. (Courtesy of B.H.A.)

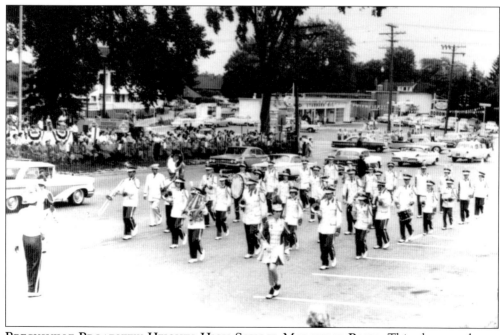

BRECKSVILLE-BROADVIEW HEIGHTS HIGH SCHOOL MARCHING BAND. This photograph was taken at the Sesquicentennial Parade in 1961. (Courtesy of B.H.A.)

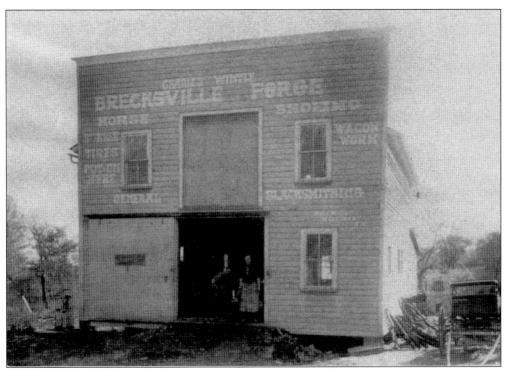

BRECKSVILLE FORGE. The foundry was located on Chippewa Creek east of Royalton Road. (Courtesy of Jerry N. Hruby.)

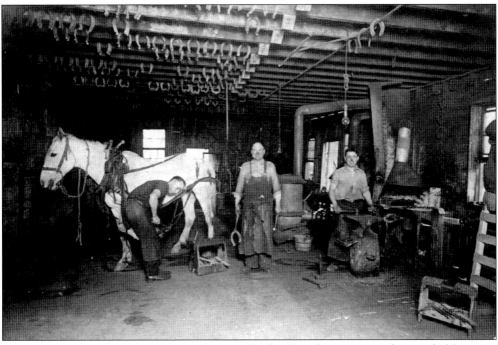

INTERIOR OF BRECKSVILLE FORGE. Owner Charles Wintle is seen at the anvil. (Courtesy of Jerry N. Hruby.)

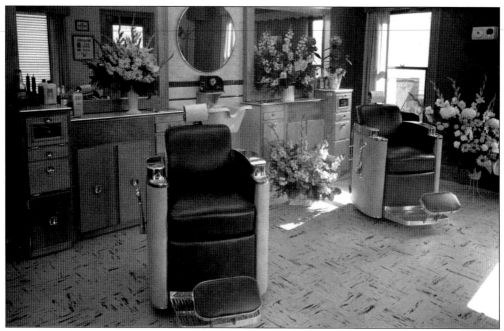

ELTON LUBE BARBER SHOP, LOCATED IN A HOUSE ON CHIPPEWA ROAD. Elton was not only a popular haircutter, but a committed Brecksville citizen who conducted the Congregational Church choir and was a founding member of the Brecksville Kiwanis. (Courtesy of B.H.A.)

CENTURY TREE. Located in the yard of Elton and Kay Lube on Snowville Road, this tree, known to be more than 100 years old at the time, was photographed in May 1960. Many other trees of its age would be cut down when the road was widened and re-graded in the 1980s. (*Cleveland Press*, courtesy of Special Collections, Cleveland State University.)

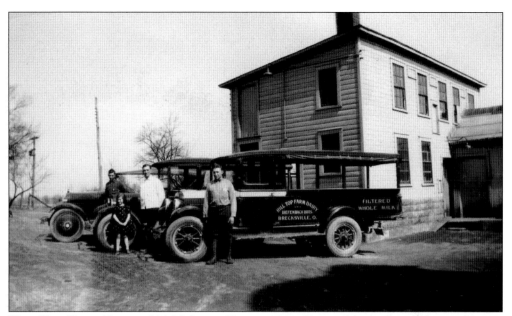

HILL TOP FARM DAIRY, 5914 MILLER ROAD, 1928. Pictured here, from left to right, are: Johnny Kaves, Doris Diefenbach, Herman Diefenbach, and Ted Diefenbach. According to Dorcas Snow, this was the "first and only dairy in Brecksville" and one of the first in the area to homogenize milk. The business was founded in 1925. Lacking electricity at first, the workers had to use steam power for the pasteurizing and bottling equipment. This photograph was taken not long after the building was enlarged and a loading platform added. (Courtesy of B.H.A.)

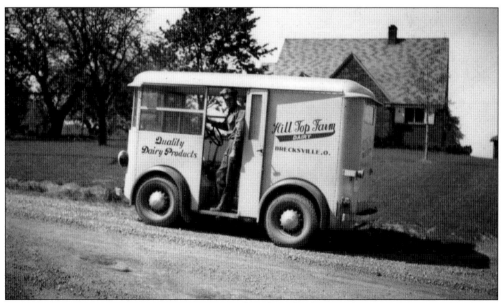

HILL TOP FARM DAIRY TRUCK. In 1938, the dairy had moved to 8913 Brecksville Road. Herman Diefenbach sold the business to Dairy Dell in 1951. (Courtesy of B.H.A.)

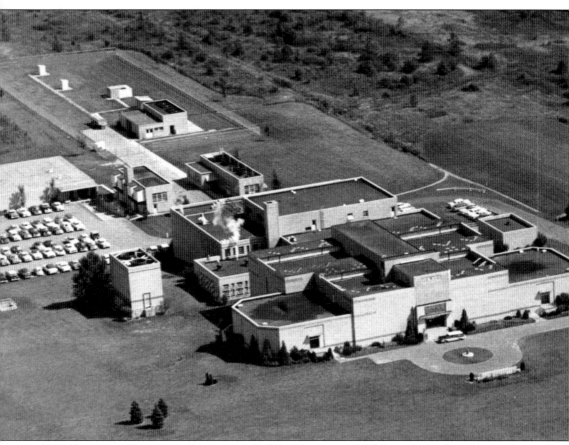

B.F. GOODRICH RESEARCH CENTER, 1953. The largest research laboratory in the rubber industry opened in June 1948 on 314 acres south of the Village, on a swell overlooking the Cuyahoga Valley. Brecksville was chosen after a survey of almost 100 sites, to insure a spot where noise, dirt, and vibration would not interfere with the scientific work of the staff and the delicate instruments used. The seven original Mercury astronauts came to the Research Center to test their space suits. The author's father worked here in the 1960s and 1970s. (Courtesy B.H.A.)

COUNTRY COUNTER. The grocery store opened in Brecksville Shopping Center on September 26, 1962, with Paul Vaughn as manager. His brother Ralph had founded the original Richfield store in 1947. (Courtesy of B.H.A.)

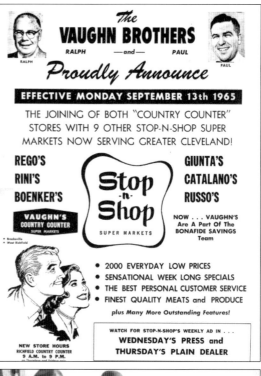

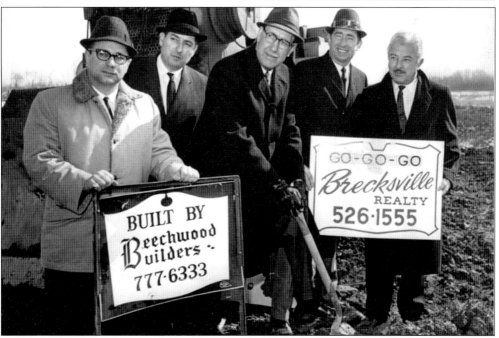

MODERN DEVELOPMENT IN FULL SWING. Shown at this groundbreaking ceremony from March 9, 1967, from left to right, are: Paul Stanley of Beechwood Builders, Peter L. Krustchnitt of Citizens Federal, Brecksville Mayor William J. Gourley, John C. Scuba of Brecksville Realty, and John L. Piszczor from Beechwood Builders. (*Cleveland Press*, courtesy of Special Collections, Cleveland State University.)

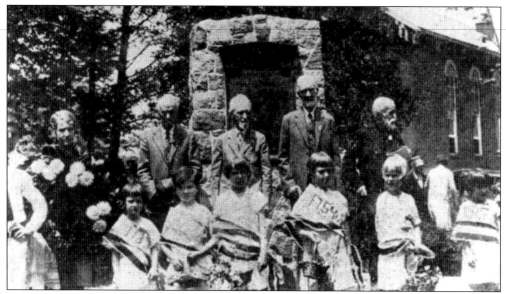

FOUR CIVIL WAR VETERANS FROM BRECKSVILLE. This photograph, taken on June 29, 1929, finds the old vets in their 80s, at least. Their names, along with those of many others who had fought in that conflict, had been inscribed just two years earlier on the War Memorial in Brecksville's Public Square. Shown here, from left to right, are: William Avery, Dr. W.A. Knowlton, Will Garman, and Thomas Rudgers. (Courtesy of B.H.A.)

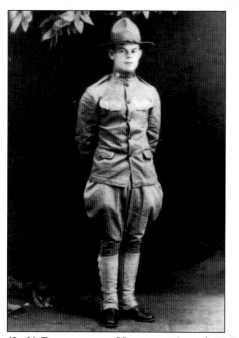
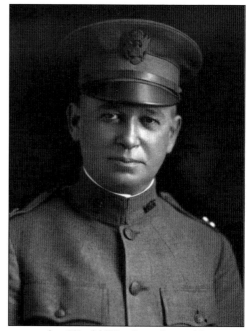

(Left) **BRECKSVILLE VETERAN.** Joseph T. Reiner wears his World War I uniform. (Courtesy of Cheryl A. Rudolph.)

(Right) **DR. THEODORE BRECK (1866–1934) IN WORLD WAR I UNIFORM, 1917.** The horse-and-buggy doctor, one of Brecksville's most fondly-remembered citizens, served as a captain in the Great War. (Courtesy of B.H.A.)

80

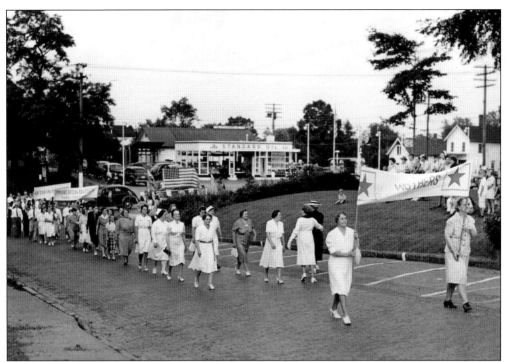

BRECKSVILLE WOMEN MAKING A STATEMENT. Mothers march in Brecksville during National Civil Defense Week, July 1942. (*Cleveland Press*, courtesy of Special Collections, Cleveland State University.)

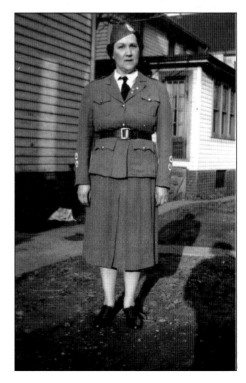

VERDA BARNES BRATTON IN HER SERVICE CORPS UNIFORM. The exact organization of which she was a member has not been determined, but this could be the uniform of an Air Raid Warden. The photograph was taken in 1944. (Courtesy of B.H.A.)

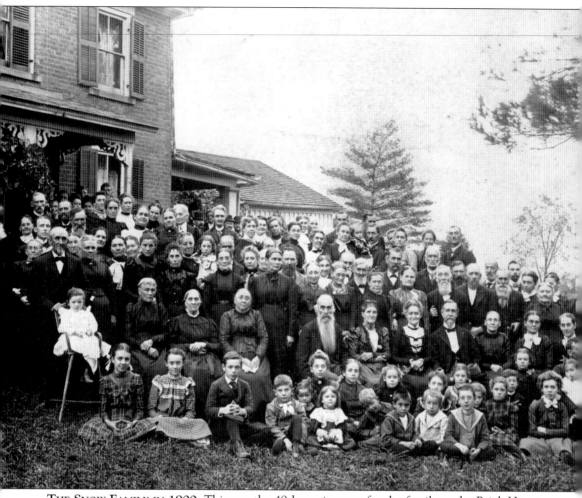

THE SNOW FAMILY IN 1900. This was the 49th anniversary for the family at the Brick House on Snowville Road. (Courtesy of B.H.A.)

Four

PEOPLE AND
CELEBRATIONS

Several decades ago, the late Brecksville historian and piano teacher Dorcas Snow wrote nostalgically of her youth: "Those were the days when we lived miles apart from our neighbors but knew them all. Now, they're right under your window and we don't even know their last name." Such is the case almost everywhere today, yet Brecksville has succeeded to a greater degree than most rapidly developing cities in keeping a "small town" flavor. Members of most of the families that settled in Brecksville in the early decades have kept a strong presence in town, and marriages between these families over the years have only strengthened the local connections. A series of reunions, festivals, and holiday events help to gather residents together on a regular basis. This in turn adds to a determination to preserve as many elements of Brecksville's past as possible.

No book of this scope can give sufficient attention to all of the families that have played prominent parts in Brecksville history and society; Dorcas Snow's books and the Brecksville Historical Association's "Reminiscent History of Brecksville" have fortunately preserved a great many recollections of family histories and activities.

In other chapters, there is mention of pioneer families such as the McCreerys and the Fitzwaters; the following pages contain photographs of Dr. Theodore Breck, the Snow family (Brecksville's earliest settlers, after whom Snowville Road is named), and gatherings that brought local residents together on a yearly basis: the 1911 Centennial and 1961 sesquicentennial; and Memorial Day parades, Home Days, Fall Festivals, and other annual events that mark the seasons in Brecksville. Images of local music, drama, and other entertainment have their place here as well.

A Local Icon, Dr. Theodore Breck. The great-grandson of the town's original namesake, born on December 1, 1867, was a beloved country doctor, driving his horse and buggy over a wide area to make house calls in several nearby communities. He delivered most of the babies in Brecksville over a 40-year span. Dr. Breck volunteered for World War I and served with distinction as a captain. (Courtesy of B.H.A.)

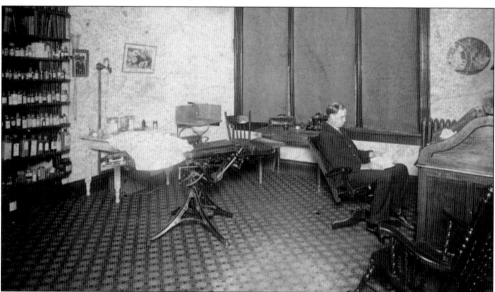

Dr. Breck's Office. For a time he had a practice in Lorain, and this photograph was taken there. Dr. Breck was a committed citizen of Brecksville, directing the Congregational Church choir and producing performances of Gilbert and Sullivan operettas. He was the keynote speaker at the 1911 Centennial celebrations and gave a stirring address. His sudden and unexpected death from appendicitis, which occurred on June 13, 1934, stunned the residents of Brecksville. The Village organized a solemn public funeral and requested businesses to close for the day. Dr. Breck was the last of the Breck line to live in the City. (Courtesy of B.H.A.)

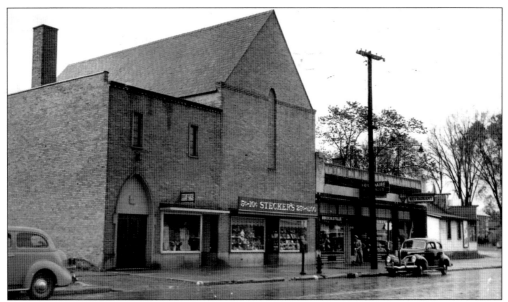

THEODORE E. BRECK MASONIC LODGE, OCTOBER 1941. After Dr. Breck's death in 1934, the lodge took his name to honor his memory. The building that housed Stecker's and the building to its left were built by George R. Klein, a pillar of the Brecksville Community. (*Cleveland Press*, courtesy of Special Collections, Cleveland State University.)

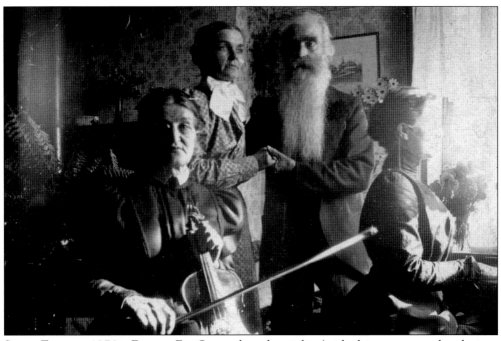

SNOW FAMILY, 1870S. Frances Fay Snow plays the violin (with the very unusual technique that she had adopted while learning to play as a child), while her husband Owen dances with their daughter Emma. She played for the public from time to time at the Brecksville Hotel. Daughter Fanny, an accomplished composer of songs who is seen here playing the keyboard, later married Dr. William Augustus Knowlton the younger. (Courtesy of B.H.A.)

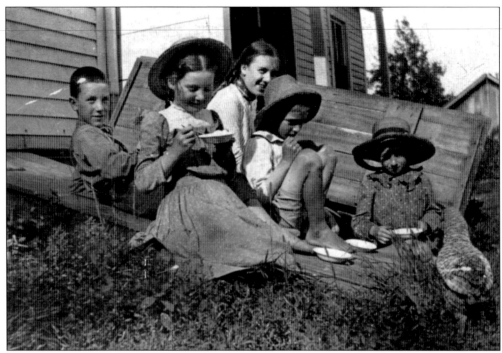

HOMEMADE ICE CREAM ON A HOT SUMMER DAY. Here are members of the Snow family in 1900, from left to right, Milton, Jeannette, Charlotte, Don Knowlton, and Hibbard. (Courtesy of B.H.A.)

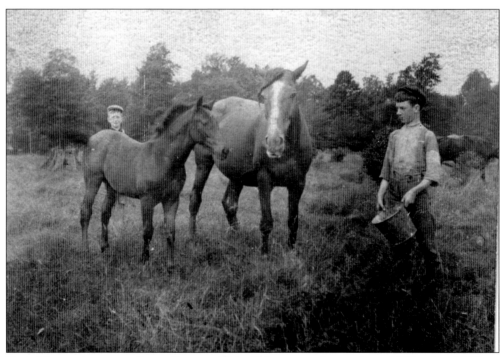

TWO MEMBERS OF THE SNOW FAMILY. This 19th-century image shows Hibbard and Milton Snow. (Courtesy of B.H.A.)

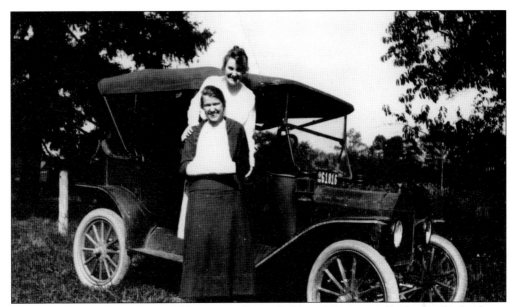

Two Jeannettes, c. 1920. Of Jeannette Snow (left) and Jeannette Eucher, only the latter learned to drive this Ford; in fact, she once broke her arm cranking the engine! After a year at Oberlin College, Jeannette Eucher opted to attend business school and became a teller at the new Brecksville Bank in 1919. (Courtesy of B.H.A.)

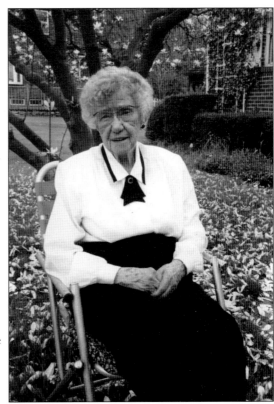

Jeannette McCreery Eucher, 100 Years Old, Spring 2001. Eucher was the oldest member of the Brecksville Historical Association for many years before she passed away in October 2001. (Courtesy of Shirley Eucher Elish Collection.)

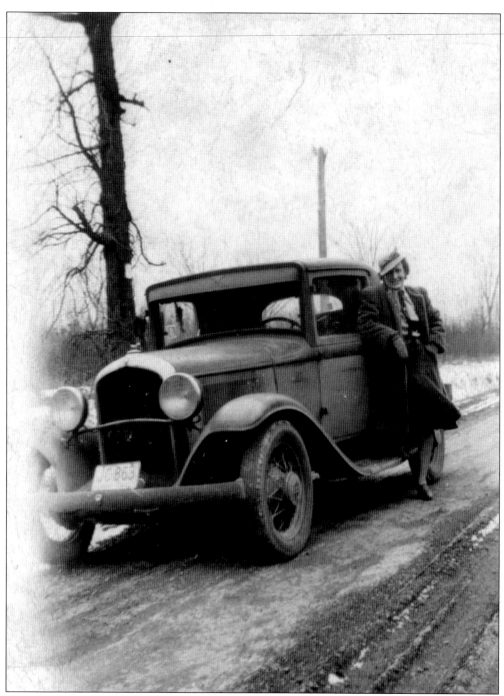

DORCAS SNOW. Remembered as both an historian and a musician, Dorcas Lavina Snow was a piano teacher in Brecksville for over seven decades prior to her death at age 91 in 1994. Snowville Road in Brecksville is named after her great-grandfather, Henry Holland Snow. In a lasting tribute to Dorcas, her class of 1994 carried on with the honored tradition of a recital of her students. Dorcas published several books about the history of Brecksville and encouraged residents to send her their family reminiscences for publication. (Courtesy of B.H.A.)

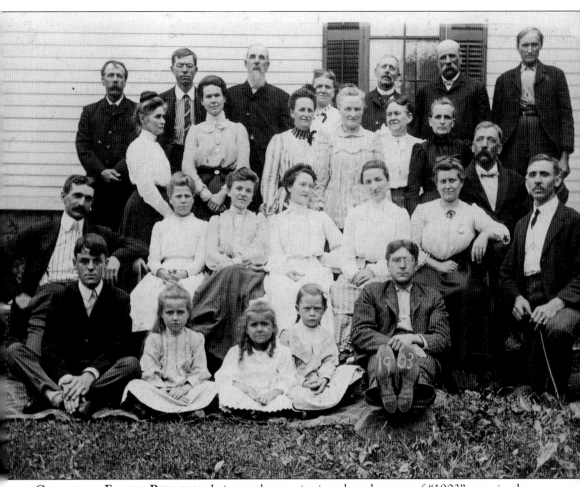

CHAVALIER FAMILY REUNION. It is worth mentioning that the year of "1903" seen in the photograph was not added later, but had actually been chalked onto the man's pair of shoes! (Courtesy B.H.A.)

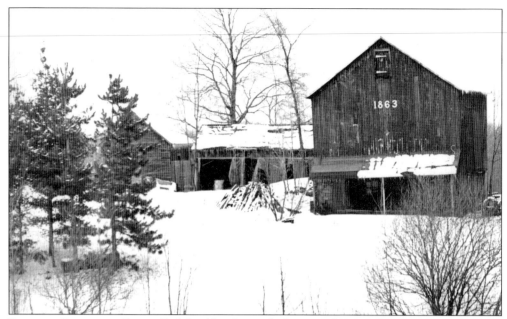

BARN ON SNOWVILLE ROAD. Built by Alex Snow, the barn was later on the property of Elton and Kay Lube. (*Cleveland Press*, courtesy of Special Collections, Cleveland State University.)

AN HISTORIC STRUCTURE IS RESURRECTED. Work proceeds on the restoration of the foundation of the Snow Barn on Snowville Road in 2003. (Courtesy of B.H.A.)

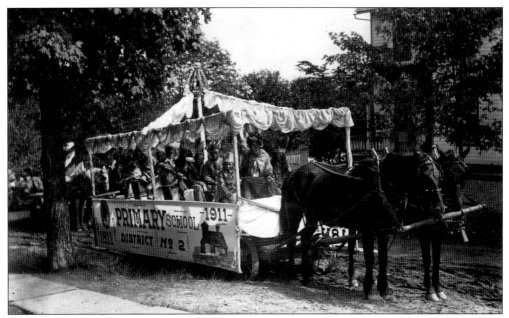

1911 CENTENNIAL PARADE. Grand Marshal Thomas J. Rudgers led a procession that included 46 horses and eight ponies. Each of the nine school districts built its own float, as in the case of School District No. 2 here. A "log cabin" was built for the purpose of displaying frontier memorabilia on the Square. (Courtesy of B.H.A.)

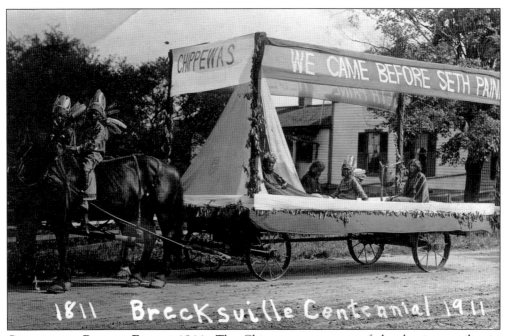

CENTENNIAL PARADE FLOAT, 1911. The Chippewas were one of the dominant tribes in the area of Brecksville before white settlers arrived. This group was enacting a portrayal of Chippewas. (Dorcas Snow Collection, courtesy of B.H.A.)

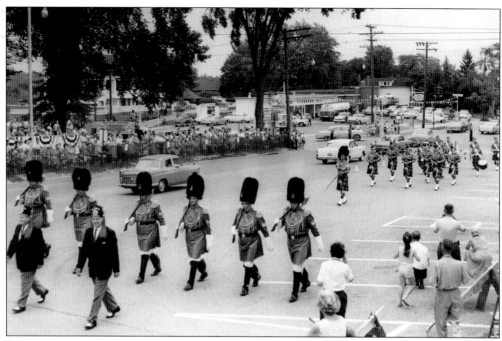

SESQUICENTENNIAL PARADE, 1961. The Shrine Beefeaters and the bagpipers lent special charm to this celebration. (Courtesy of B.H.A.)

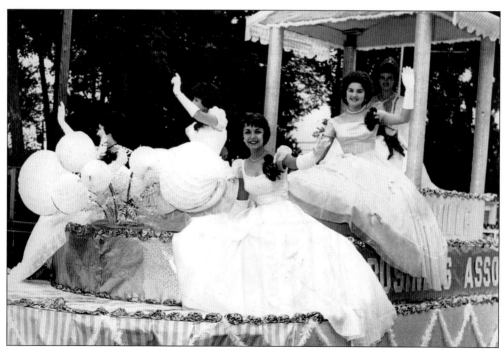

SESQUICENTENNIAL FLOAT, JULY 1961. The queen of the parade was Phebe Klein. Her court consisted of Sandra Dudl, Barbara Ann Leiblinger, Mary Russell, and Lynn Sauters. A major advantage in 1961, compared to 1911, was motor-driven floats! (*Cleveland Press*, courtesy of Special Collections, Cleveland State University.)

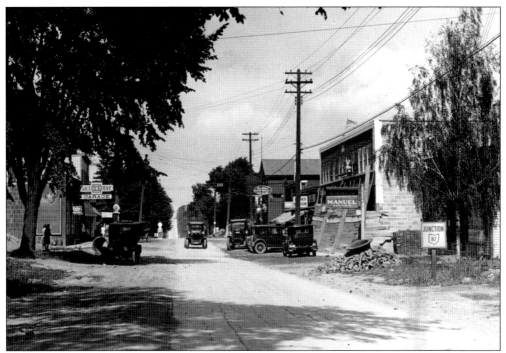

STREET SCENE, 1928. This photograph shows the construction of the Young Building (at right) prior to the widening of Route 21. (*Cleveland Press*, courtesy of Special Collections, Cleveland State University.)

FRIENDSHIP CLUB, SUMMER 1920. This was a social function of the Brecksville Congregational Church. In the front row, from left to right, are: Edith Jones, Emily Spirek, Lydia Barton. In the back row, from left to right, are: Eunice O'Connor, Gladys Newton, Betty Dillow, Dorcas Snow, Virginia Jaite, and Louise Coates. (Courtesy of B.H.A.)

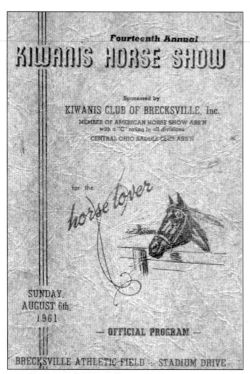

KIWANIS HORSE SHOW PROGRAM, 1961. After the end of the Home Days tradition (see pp. 97–98), the Horse Show was instituted in 1949 to take its place. (Courtesy of B.H.A.)

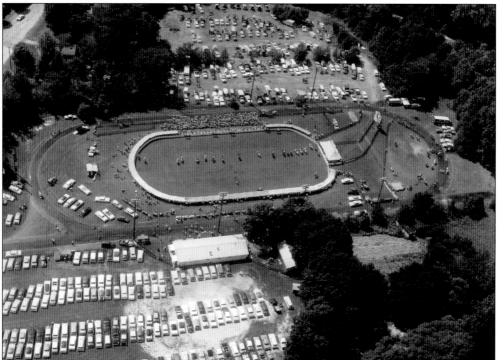

KIWANIS HORSE SHOW, AUGUST 2, 1959. Prior to the construction of the Fox Rest condominiums, the Horse Show was held in a single ring, located at the high school football field on Stadium Drive. (*Cleveland Press*, courtesy of Special Collections, Cleveland State University.)

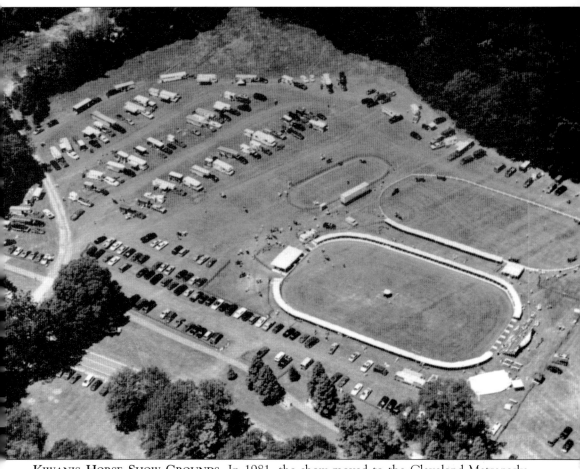

KIWANIS HORSE SHOW GROUNDS. In 1981, the show moved to the Cleveland Metroparks Brecksville Reservation and expanded to three rings. (Courtesy of B.H.A.)

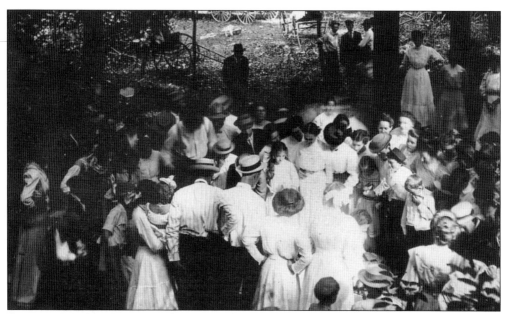

POPCORN EATING CONTEST. This occurred at a Sunday School Picnic in approximately 1908. (Courtesy of B.H.A.)

DICKENS SOCIETY, UNDATED. These amateur Brecksville actors brought Dickens' characters to life in many enactments of his works, which were staged at Town Hall. (Courtesy of B.H.A.)

WASHINGTON'S BIRTHDAY CELEBRATION, LATE 1800S. Some historians believe that the boy in uniform at right is the future Dr. Theodore Breck. (Courtesy of B.H.A.)

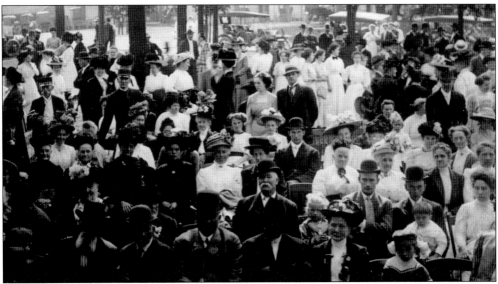

HOME DAY FAIR, SEPTEMBER 1910. Many Brecksville residents began finding work in Cleveland by 1900, and moving there too, because transportation was not rapid enough for commuting. As a result, in 1901, the "Brecksville Association of Cleveland" was created to foster a sense of community amongst displaced Brecksvillites. This developed into the idea of an organized annual reunion back home in Brecksville, which first occurred in August 1904. (Courtesy of B.H.A.)

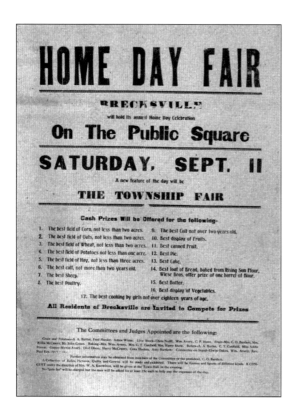

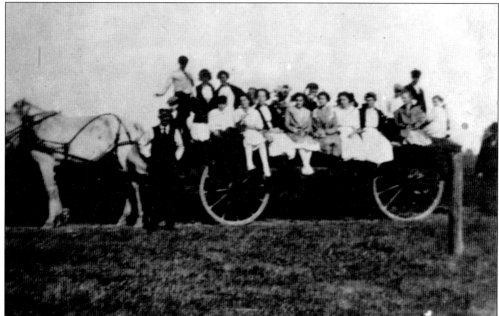

HOME DAY FAIR

BRECKSVILLE

will hold its annual Home Day Celebration

On The Public Square

SATURDAY, SEPT. 11

A new feature of the day will be

THE TOWNSHIP FAIR

Cash Prizes Will be Offered for the following—

1. The best field of Corn, not less than two acres.
2. The best field of Oats, not less than two acres.
3. The best field of Wheat, not less than two acres.
4. The best field of Potatoes not less than one acre.
5. The best field of Hay, not less than three acres.
6. The best calf, not more than two years old.
7. The best Sheep.
8. The best Poultry.

9. The best Colt not over two years old.
10. Best display of Fruits.
11. Best canned Fruit.
12. Best Pie.
13. Best Cake.
14. Best loaf of Bread, baked from Rising Sun Flour, Wiese Bros. offer prize of one barrel of flour.
15. Best Butter.
16. Best display of Vegetables.

17. The best cooking by girls not over eighteen years of age.

All Residents of Brecksville are Invited to Compete for Prizes

The Committees and Judges Appointed are the following:

HOME DAY FAIR HANDBILL. A picnic was laid out in Public Square during Home Days, with refreshments in the churches, musical entertainment, a show of farm products, and a big tub of ice cream. (Courtesy of B.H.A.)

A HAY RIDE AROUND THE SQUARE, HOME DAY, 1922. As Brecksville grew into a city, Cleveland-based Brecksvillites' interest in returning for Home Days diminished, and the festivals were discontinued in 1947. Modern "home days" were reintroduced in the 1980s as Fair on the Square, which was run by the Lions Club through 1997. Beginning in 1998, it was again sponsored by the City of Brecksville and became known once more as "Home Days." (Courtesy of B.H.A.)

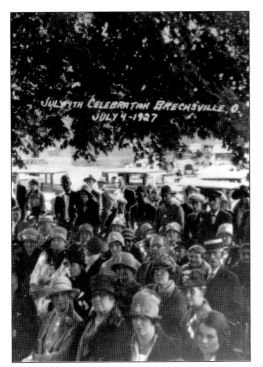

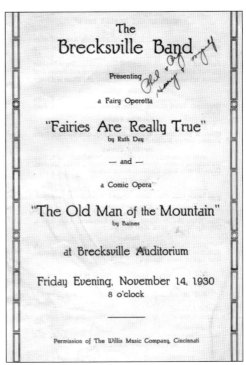

(*Left*) JULY 4TH CELEBRATION, 1927. As with Home Days, a tradition grew of celebrating Independence Day in the Square. (Courtesy of B.H.A.)

(*Right*) BAND CONCERT PROGRAM, 1930. The Brecksville Band was organized in 1927 by James Grieves, a steelworker from Scotland who had been trained in music in his youth. (Courtesy of B.H.A.)

BRECKSVILLE BAND, C. 1930, IN FRONT OF THEODORE BRECK HOUSE. The Brecksville Band, composed of students and adults, played for Independence Day, Home Days, and Memorial Day for several years. When James Grieves retired, Clyde Seidel became its leader. (Courtesy of B.H.A.)

LITTLE THEATRE PROGRAM, 1953. Performances took place at Brecksville High School. "BLT" has been an integral part of the community for more than 60 years. (Courtesy of B.H.A.)

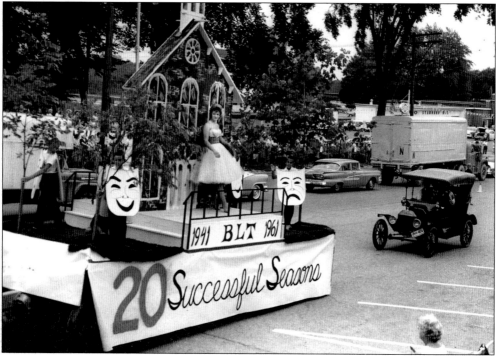

BRECKSVILLE LITTLE THEATRE PARADE FLOAT. The BLT came into being on April 18, 1941, when a group of amateur actors presented three one-act plays on the High School stage. (Courtesy of B.H.A.)

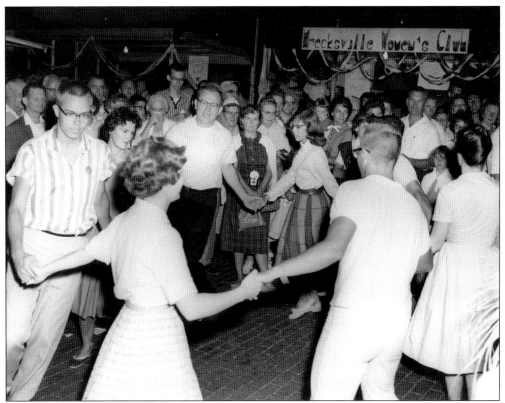

SESQUICENTENNIAL SQUARE DANCE, 1961. This event was put on by the Brecksville Women's Club. (Courtesy of B.H.A.)

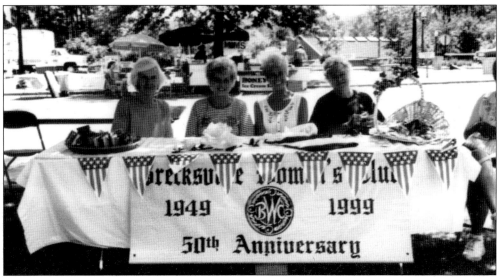

BRECKSVILLE WOMEN'S CLUB. The group was celebrating its golden anniversary. at the 1999 Home Days held behind City Hall. The Women's Club is a philanthropic group that takes on various causes, including offering scholarships to Brecksville-Broadview Heights students. (Courtesy of B.H.A.)

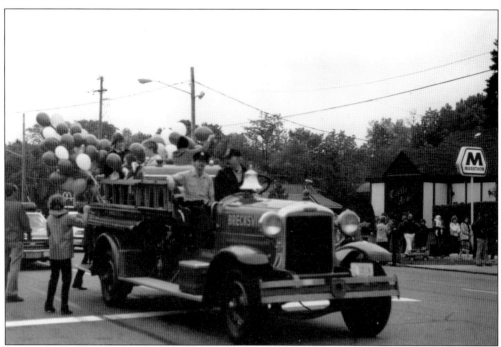

MEMORIAL DAY, LATE 1970S. This photograph was taken at Brecksville Road at Arlington. Today the Castle Arms Restaurant has been replaced by Medic Drug. (Courtesy of B.H.A.)

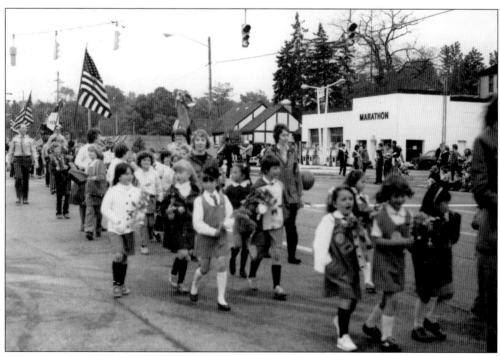

MEMORIAL DAY PARADE. Brownies and Boy Scouts, along with other civic groups, traditionally march to the Highland Drive Cemetery. The Brownie troops carry flowers to be placed on the graves of fallen veterans. (Courtesy of B.H.A.)

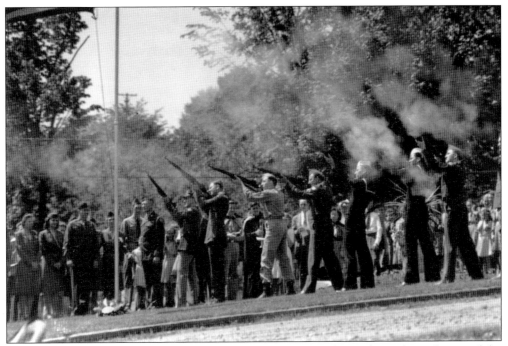

TWENTY-ONE-GUN SALUTE TO FALLEN VETERANS. This is the traditional conclusion of the Memorial Day services at Highland Drive Cemetery. (Courtesy of B.H.A.)

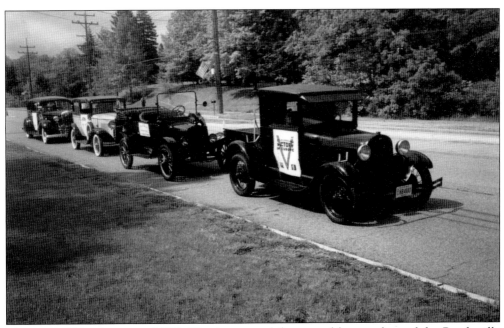

MEMORIAL DAY PARADE, 1995. Classic automobiles owned by members of the Brecksville Historical Association display photocopies of the *Cleveland Press* V-Day coverage. (Courtesy of B.H.A.)

BRECKSVILLE HISTORICAL ASSOCIATION AT THE 1995 FAIR ON THE SQUARE. Originally founded as the Brecksville Early Settlers Assocation in 1925 by C.O. Bartlett, the Brecksville Historical Association has long been dedicated to preserving the history and heritage of Brecksville and the surrounding area. It operates the Squire Rich Museum as an affiliate organization of the Cleveland Metroparks and maintains its archival collection at the Blossom Hill complex in facilities provided by the City of Brecksville. (Courtesy of B.H.A.)

MASTER CHEF. Joe Duale cooks at the annual Corn Roast in 2000. (Courtesy of B.H.A.)

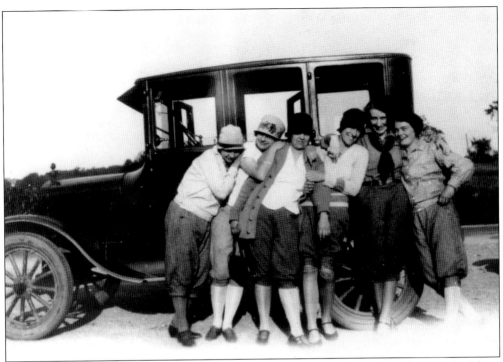

BRECKSVILLE LADIES TAKE A DRIVE. Unfortunately, the names of those photographed here were not recorded. (Courtesy of Dorcas Snow Collection.)

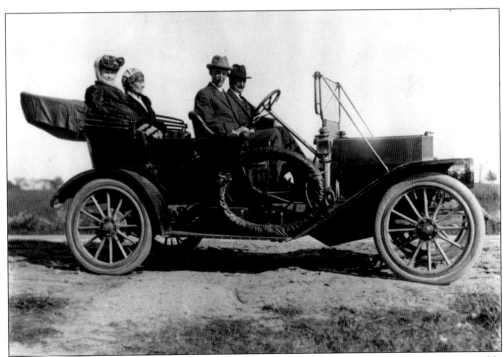

THE PLEASURES OF SLOW MOTORING. Unidentified Brecksville residents are out for a ramble in a touring car. (Courtesy of B.H.A.)

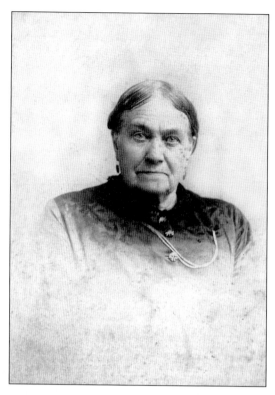

EMILY MOSES WALLACE. Emily, the daughter of Brecksville pioneers William and Phoebe Moses, married township trustee and farmer Samuel Wallace in the early 1830s. They owned 108 acres of valuable land (with two prized natural springs) by the canal. Samuel owned and operated a canal boat, *Florida*, on which the young couple also cruised for pleasure. Sadly, Samuel died at 45 in 1850, leaving Emily to support five children. She carried on, hiring hands to work the family farms, acquiring 330 acres, and becoming known as a formidable businesswoman and a generous supporter of charities; she donated $1,000 to the Congregational Church and, in 1872, lent the Township $3,000 to build the magnificent Town Hall. Emily's daughter Susannah married Edward McCreery in 1855, linking together two well-respected families, and their descendants have carried on Emily's tradition of service to the community. (Jeannette McCreery Eucher Collection.)

WOMEN WITH BICYCLES, EARLY 1900S. They are, from left to right: Ruby Chavalier, Lila Chavalier, and their neighbor Virginia McCreery. Lila and Ruby, the daughters of Al and Hattie Chavalier (see p. 35 and p. 127), both graduated from the Oberlin Conservatory of Music and were piano teachers. In 1926, Ruby married Frank Carroll, who owned Brecksville Hardware until its closure in 1951. (Courtesy of B.H.A.)

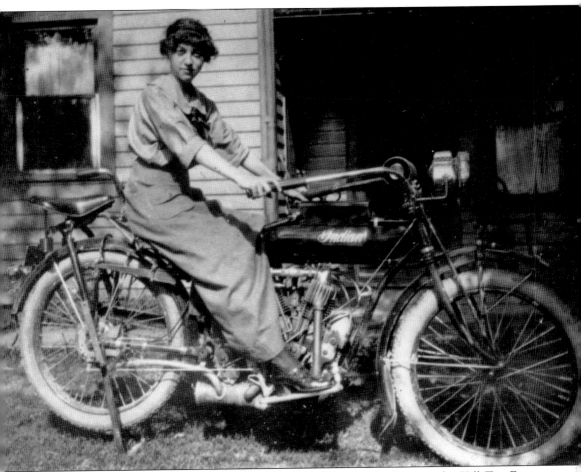

FLORENCE DIEFENBACH, 1895–1983. A member of the family that ran the Hill Top Farm Dairy (see p. 77), Florence married Forrest Elmer, who worked at the Jaite Paper Mill, in 1915. Florence waitressed at the Spanish Tavern and the Stage House. Deeply involved in the community, she also taught at the Snow School and was a charter member of the Brecksville Garden Club. In her mid-80s, still adventurous, she traveled to Europe. Her daughter, Arlene Elmer Griffith, has contributed photographs to this book. (Courtesy of B.H.A.)

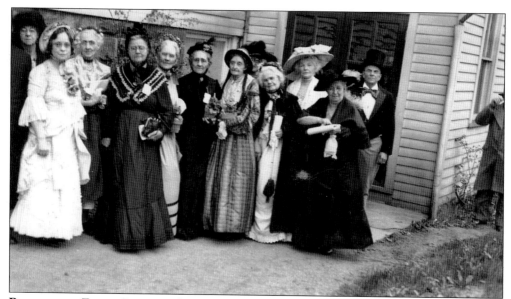

BRECKSVILLE EARLY SETTLERS ASSOCIATION, MAY 1938. This organization was the creation of C.O. Bartlett, who wished to keep the memory of local settlers' traditions alive. The group's first meeting was in 1925. (Courtesy of B.H.A.)

BRECKSVILLE EARLY SETTLERS HISTORICAL ASSOCIATION. This photograph was taken at the annual meeting held on June 24, 1944. In 1978, the Early Settlers Historical Association was incorporated as the Brecksville Historical Association. (Courtesy of B.H.A.)

ORIGINAL BRECKSVILLE TOWNSHIP FIELD NOTES. Alfred Wolcott kept these notes during the surveying of Brecksville Township in 1811, before land was partitioned out. Theodore Breck donated these notes (50 pages in all) to Cuyahoga County in 1886. (Courtesy of B.H.A.)

JOHN HOWARD TUCKER CHORUS, 1956. Tucker (left), a talented and locally celebrated musician, was the music director at the Brecksville Schools and conducted musicals at the Brecksville Little Theatre. (Courtesy of B.H.A.)

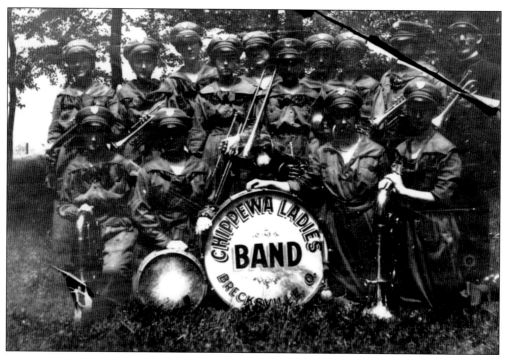

CHIPPEWA LADIES' BAND C. 1915. A group of 18 enterprising young women (not all seen in this undated photograph) caused a stir in Brecksville when they launched this fine ensemble and raised their own funds—for instance, organizing a public supper to pay for the purchase of the bass drum seen here. All of the women were pianists, but they had to learn band instruments from scratch. Quoth the local newspaper: "Residents say that when the band practices Saturday afternoons in the school it is almost as exciting in the village as on 'home' day." (Courtesy of B.H.A.)

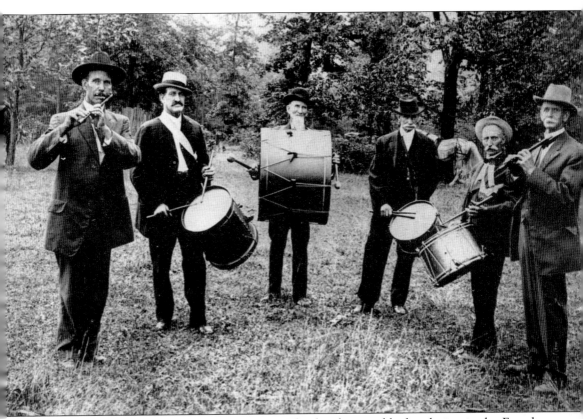

GOLDWOOD FIFE AND DRUM BAND, 1914. This band is notable for playing in the French and Indian War, the Revolutionary War, the War of 1812, and the Civil War. The band was the oldest known fife and drum ensemble of its kind, with special heritage attached to its 250-year-old hickory Continental snare drum. During the War of 1812, John DuKane was killed in action while playing it. The drum next came into the possession of Chauncey Ellsworth, a soldier in that same war, whose descendants now live in Brecksville. Later it passed to John Goldwood Sr., who started the Riley Martial Music Band in Hinckley (in which Brecksville's Beecher Bell, father of Harriet Coates, played the bass drum). After John's death in 1888, his son Frank (at left in this photograph) led the group, which played all over northeast Ohio. Seven members of this band are buried in West Richfield, Ohio. (Courtesy of B.H.A.)

COONRAD HOUSE. This house at 10340 Riverview Road belonged to Jonas Coonrad. The 1874 Brecksville map shows this property to be a 200-acre dairy farm and cheese factory adjoining the Snow Farms. It was listed as having 500 cows—a massive operation for its time. Located in rich bottom land along the Cuyahoga River, it was conveniently situated for shipping cheese products out on the canal and, later, the Valley Railroad. Today the house serves as Ranger Headquarters in the Cuyahoga Valley National Recreation Area. (Courtesy of Estate of Elizabeth B. Hoffman.)

Five

BRECKSVILLE'S HISTORIC HOMES

While one-third of Brecksville's 19.5 square miles is preserved as parkland, a drive around the City's residential areas reveals that the beauty of the rolling, tree-filled land extends to the neighborhoods as well. The older houses blend into the hilly greenery as gracefully as Town Hall and the Brick Store do in the center of the modern downtown shopping area. Built to last from sturdy local wood, these houses have endured well the northeast Ohio winters and in some cases, multiple renovations.

Certain houses (the Fitzwater house on Riverview Road, for instance) have appeared in other chapters and are not found here. Most of the photographs in this chapter were taken many years ago and do not reflect more recent changes to the houses shown. Some houses, indeed, are gone entirely now. In the case of homes that are still private residences, the street addresses have not been listed out of respect for the privacy of the current owners, nor have those owners been identified. For the same reason, newer comparison photographs of the same houses have not been included.

It is important to give credit to Elizabeth B. Hoffman, President of the Brecksville Historical Association from 1957–1959, for her pioneering work in collecting much of this information in the early 1960s.

THE BRICK HOUSE, ALSO CALLED THE SNOW HOUSE. Many generations of the Snow family have lived in this house, which was built in approximately 1845 by Russ Snow. The bricks for its 14-inch thick walls were made and fired at the construction site. Restored after a bad fire in 1964, the house is now listed on the National Register of Historic Places. (Courtesy of B.H.A.)

THE NEWLAND HOUSE. Built c. 1850, this house on Brecksville Road was purchased by the Newland family during the Civil War. It had a spinning room, a very large kitchen, and five bedrooms. (Courtesy of the Estate of Elizabeth B. Hoffman.)

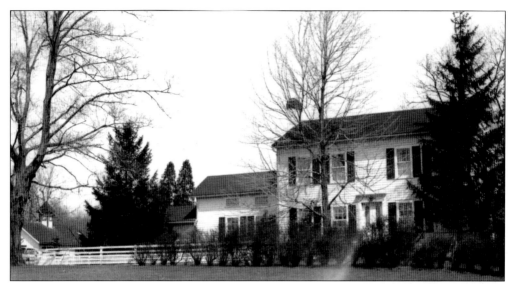

"INMAN HOUSE" (OR "CHURCH HOUSE"), BRECKSVILLE ROAD. Part of the large Inman farm that stretched back to Whitewood Road in the 1870s, this house is thought to have been built in the 1830s, but interior remodelings over the years have removed much of the evidence of its origins. It was used for some years as a double house. (Courtesy of the Estate of Elizabeth B. Hoffman.)

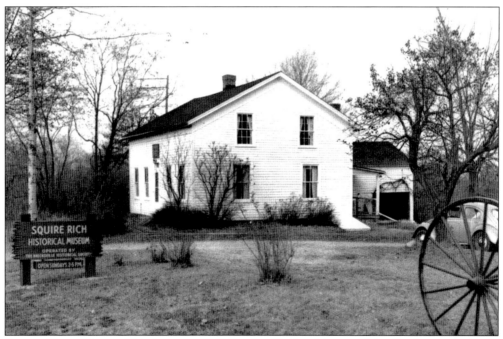

SQUIRE RICH HOUSE. This house at 9367 Brecksville Road is one of the City's most enduring landmarks. Built c. 1835 and listed today on the National Register of Historic Places, it was originally home to Charles B. Rich, a farmer who served Brecksville as its first Justice of the Peace and also a Trustee. It has been called the Squire Rich Historical Museum since 1961. A burst water pipe in March 1996 caused major damage, necessitating an extensive reconstruction (see next page). (Courtesy of B.H.A.)

SQUIRE RICH HISTORICAL MUSEUM BEFORE RESTORATION. This photograph shows the dining room, the pantry, and the stairs. Sixty-eight donors contributed $4,500 to augment the $32,000 in insurance for the repairs, and many volunteers labored on the comprehensive makeover that the house received. (Courtesy of B.H.A.)

SQUIRE RICH HISTORICAL MUSEUM AFTER A YEAR OF RESTORATION, 1997. This is a slightly different view of the same part of the house, after an immense amount of work has been put in to restore the building not only to structural soundness but also to an accurate historical condition. Visitors to the museum today enter the world of a Brecksville farming family in the mid-19th century, full of authentic artifacts of the period. Clients waited their turn to settle their claims on the long bench seen here. The museum was re-dedicated with much festivity on May 18, 1997, and tours and educational activities have continued. (Courtesy of B.H.A.)

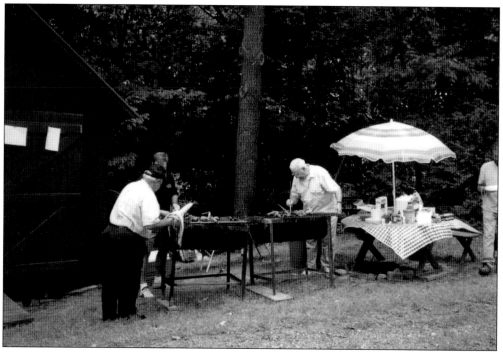

CORN ROAST. The 2001 festival was held on the grounds of the Squire Rich Museum. (Courtesy of B.H.A.)

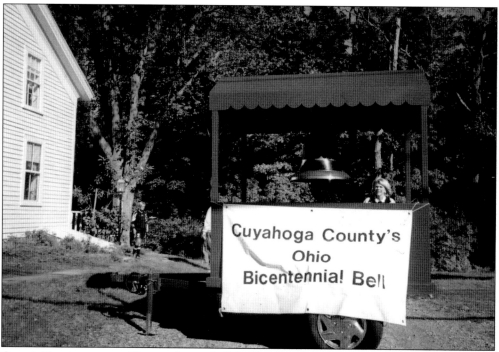

OHIO'S BICENTENNIAL. The newly cast bell for the 2003 celebrations is temporarily on display next to the Squire Rich Museum at its October Apple Butter Festival. (Courtesy of B.H.A.)

RUST FAMILY HOUSE, 1960. Ed Rust, who bought land in Brecksville in 1828, built this house in 1861. The family often lent out rooms to travelers and stabled their horses as well. In 1945, the land on which it stood was purchased by B.F. Goodrich for its planned Research Center, necessitating the house's removal further south on Brecksville Road. The front porch was added at that time. (Courtesy of the Estate of Elizabeth B. Hoffman.)

THE SAME HOUSE PHOTOGRAPHED IN 1972. After being moved to Brecksville Road, the house remained a residence until the land was rezoned. In the mid-1960s, it became a commercial property and was converted to the full two-story structure seen here. (Courtesy of the Estate of Elizabeth B. Hoffman.)

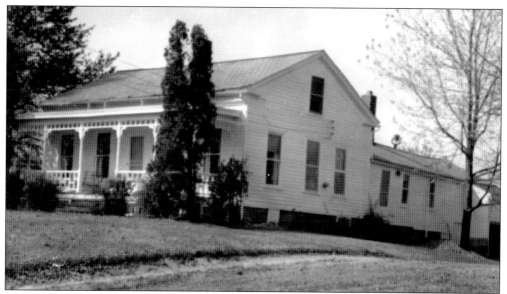

THE PERRY HOUSE, CHIPPEWA ROAD. A stagecoach driver named H.H. Perry built this house in 1839 without a foundation. The porch seen here was added in the 1880s, and nearly 50 years later, the Perry family had the house moved back from the road and placed on a foundation, adding a wing in the process. (Courtesy of the Estate of Elizabeth B. Hoffman.)

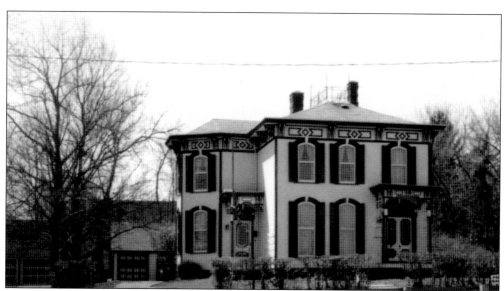

THE KNOWLTON-BOURN HOUSE. This Italianate-style house on Old Highland Drive, with its distinctive bracketed cornice and tall first-floor windows, was built in 1879 for Dr. William Knowlton, a Civil War veteran. Dr. Ernest Bourn, Knowlton's protégé, purchased his practice and his house in 1890. The house is listed on the National Register of Historic Places. (Courtesy of B.H.A.)

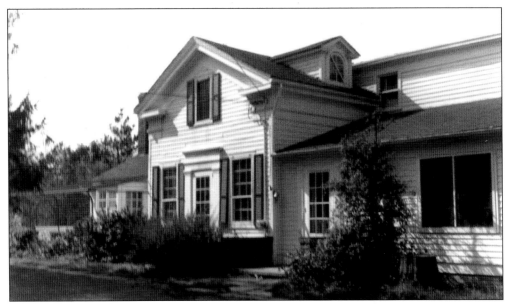

CATHERINE DILLOW HOUSE, CHIPPEWA ROAD. This house, along with two others for Catherine's brothers, was built *c.* 1835–1840. When Catherine married Ira Fitzwater, the house was called the "Fitzwater House" by some. In 1904, the entire farm on which it stood was purchased by the Glen Valley Club (a consortium of 13 families), and the house served as the gathering place for meals. Two years later, it was moved back from the road and remodeled extensively. A new wing was added in 1952 by its owners at the time, the Listers. Further changes have been made by subsequent owners. (Courtesy of the Estate of Elizabeth B. Hoffman.)

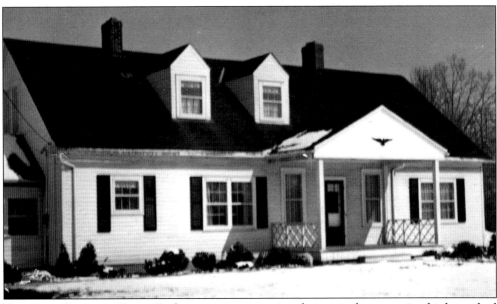

HOUSE ON CHIPPEWA ROAD. Built just over a century ago by a retired sea captain, this house had a commanding view of Route 82 below (a place now occupied by the Brecksville Shopping Center and much changed from its old configuration). The house was moved further east and rotated in 1960 so that its front faced Route 82. (Courtesy of the Estate of Elizabeth B. Hoffman.)

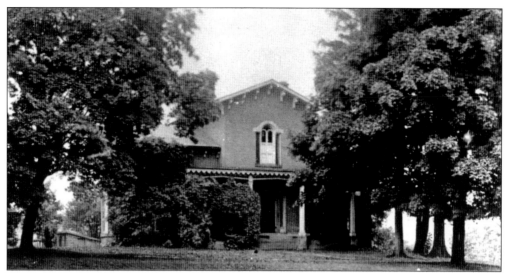

BRECK RESIDENCE ON PUBLIC SQUARE. Colonel John Breck, the New Englander who once owned much of Brecksville, never visited it, but his sons settled in the Township in 1830. The house was built for one of them, Dr. Edward Breck, in 1837 and was financed by his brother Theodore. The bricks, which formed not only the outside walls but also all interior partitions, were made in Newburgh, Ohio by a cousin. Ceilings were ten feet high. The porches were added about a century ago. (Courtesy of B.H.A.)

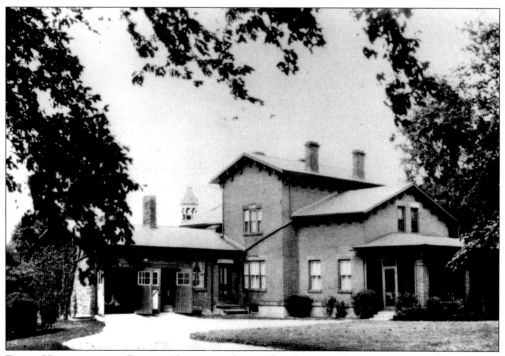

REAR VIEW OF THE BRECK HOUSE. A later Theodore Breck (1866–1934), the beloved physician and World War I veteran, lived and practiced here. While he was away at war, his wife operated an ice cream parlor and tea room in the house. Today, the house shows evidence of several modifications in past years. (Courtesy of B.H.A.)

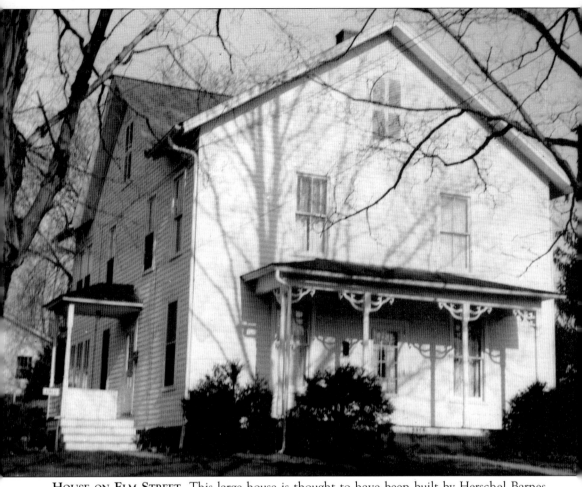

HOUSE ON ELM STREET. This large house is thought to have been built by Herschel Barnes just after the Civil War. His brother Jesse later owned both the house and the Brick Store, and Brecksville's first telephone connected the store to this house. The phone is a part of the Brecksville Historical Association's collection of artifacts in the Squire Rich Historical Museum today. (Courtesy of the Estate of Elizabeth B. Hoffman.)

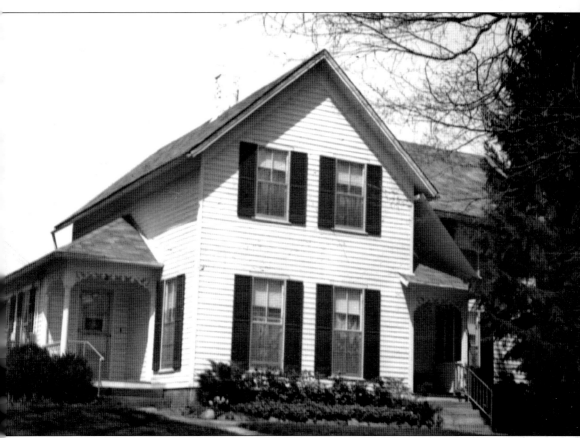

ANOTHER HERSCHEL BARNES HOUSE. This house, also on Elm, was built at roughly the same time as that on the opposite page. It was later the residence of Dorcas Snow, daughter of Harry Snow and Alice Noble Snow who had purchased it in 1916. Dorcas' piano teaching studio was located in an addition to the house. (Courtesy of the Estate of Elizabeth B. Hoffman.)

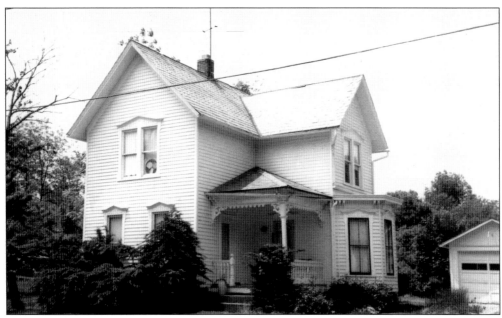

COLSON HOUSE. This house was built in approximately 1838. The 1874 map showed it to be owned by an N.J. Colson. From 1933 to 1938, the Brecksville Telephone Exchange, with Mrs. Faye Martin as operator, was located in the house. All calls went through her switchboard, and it was common for Brecksville residents to let Faye know when they would be out so that callers could be advised to try again later. In 1932, the Carrolls purchased the house from Lydia Colson. They sold it in 1957 to Walter J. Zimlich, who moved it to Cedar Street in Old Town. Mr. Zimlich in turn sold the house to Emil Kocar in 1966. (Courtesy of the Estate of Elizabeth B. Hoffman.)

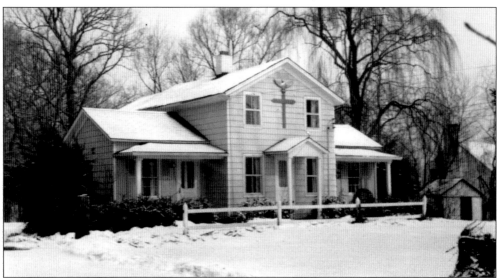

PETTIT HOME, BUILT 1850. This house on Fitzwater Road was sold in 1851 by the Pettits to John Fitzwater the elder, who gave it to his son John. John the younger married Clarinda Pratt; their son Myron lived in the house after his parents passed, and he and his wife celebrated their Golden Anniversary there in 1936. The house was remodeled beginning in the 1950s. (Courtesy of the Estate of Elizabeth B. Hoffman.)

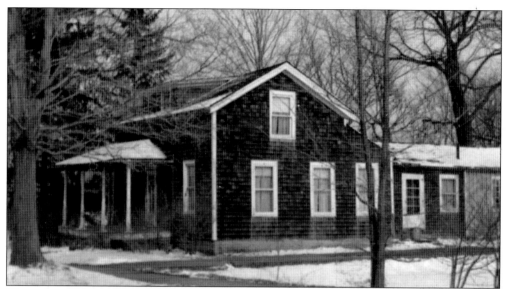

VERY OLD HOME ON HIGHLAND DRIVE. This house, which featured a log cellar and attic beams with the bark still on them, may have been built in pioneer days. The Nash family were the first owners, and Dr. Augustus Knowlton Sr. purchased the house in 1852. Subsequent owners included the Latimer, Boyd, Fritz, and Perry families. Upon inheriting the home from their mother in 1944, Mildred and Raymond Perry sold the back acreage and several other lots for the building of other homes. Mildred moved into the family home, and Raymond built a new house next door. Mildred Perry was well known to patrons of the Brecksville Library of that generation, serving as librarian from 1930–1960 and building up the local branches considerably. When she retired, she lived on in this house until she passed away in April 1967. (Courtesy of the Estate of Elizabeth B. Hoffman.)

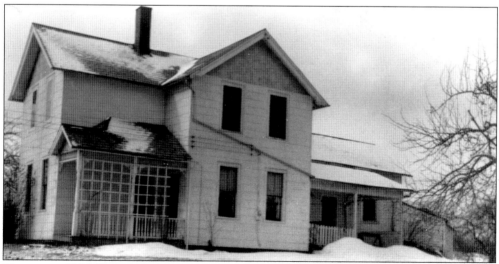

HOUSE IN 6300 BLOCK OF MILL ROAD, PHOTOGRAPHED 1962. This house is long gone, having been torn down for the Ryan Company Sunnydale development. In the 1950s, it had been owned by Vera McCreery, along with her son Lloyd and his family (who later moved to West Richfield). This area has changed beyond all recognition now. (Courtesy of the Estate of Elizabeth B. Hoffman.)

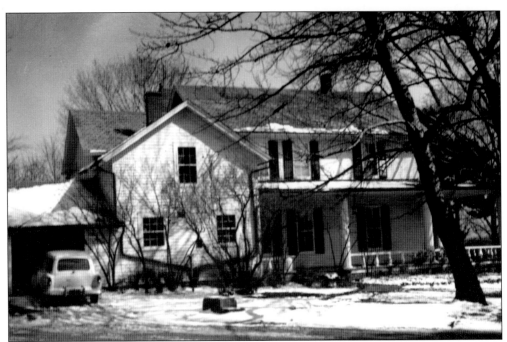

BRECK HOME ON MILL ROAD. John Adams Breck, one of the sons of Colonel Breck, settled in town in 1830, most likely building a cabin on this property first and then starting construction of the home. It appears to have been finished in 1835 and added to in 1860. Emily Wallace, who lived in this house in the 1860s and early 1870s, may have paid for the addition before she moved in. (Courtesy of the Estate of Elizabeth B. Hoffman.)

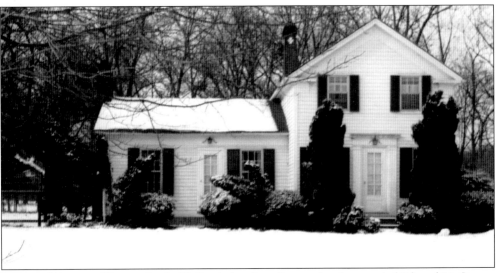

FORMER WALLACE HOUSE. Emily Wallace's daughter Susannah, who married Edward McCreery, later moved with him into this home on Fitzwater Road in the 1870s. It had been built on top of one of the two natural springs on Emily and Samuel Wallace's Valley property, and the spring was accessed right in the kitchen—a tremendous convenience at that time because it saved a trek outside. The Plechaty family moved the house back from Fitzwater to what became this Oakhurst Drive location in the 1920s. (Courtesy of the Estate of Elizabeth B. Hoffman.)

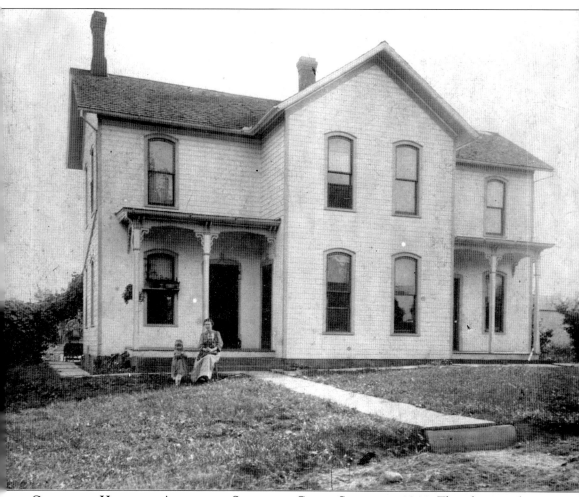

Chavalier House on Arlington Street at Cedar Street, c. 1910. This photograph shows Hattie Ann Chavalier with her daughter Lila. Hattie's husband, Al Chavalier, is the man seen driving the automobile on the cover of this book. (Courtesy of the Estate of Elizabeth B. Hoffman.)

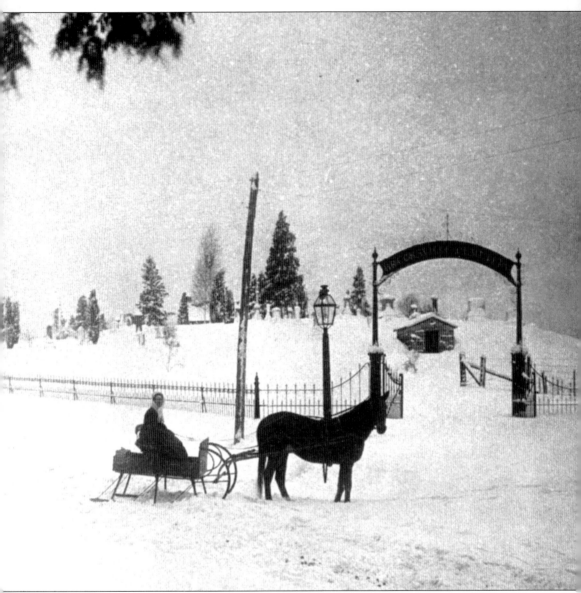

HIGHLAND DRIVE CEMETERY, c. 1905–1910. The woman seated in this sleigh can scarcely have imagined that she would become a part of one of the most celebrated historical images of Brecksville. It is a magical winter scene. (Courtesy of B.H.A.)